Posing and Lighting Techniques

For Studio Portrait Photography

J.J. Allen

AMHERST MEDIA, INC. ■ BUFFALO, NY

Copyright ©2000 by J.J. Allen
All photographs by J.J. Allen, unless otherwise noted.
All rights reserved.

Published by:
Amherst Media, Inc.
P.O. Box 586
Buffalo, N.Y. 14226
Fax: 716-874-4508
www.AmherstMediaInc.com

Publisher: Craig Alesse
Senior Editor/Production Manager: Michelle Perkins
Assistant Editors: Matthew A. Kreib and John Chojnacki

ISBN: 1–58428–031–X
Library of Congress Card Catalog Number: 00–132634

Printed in Korea.
10 9 8 7 6 5 4 3 2 1

Table of Contents

Introduction

■ A Note From the Author

Twenty years ago I worked with Photography Learning Systems, a company that produced audio-visual lessons on photography. I wondered why the company name emphasized learning rather than teaching. Finally, I caught on. Teaching is something someone else does. Learning is something we do. It is possible for my teacher to teach the best he can and, at the same time, it is possible that I won't learn a single thing.

Learning is what this is all about and learning is an interactive experience. I'll do the best I can, but unless you follow up with the recommended tests and experiments and then follow that up with practice, practice, practice, you won't learn.

There are two ways to learn photography. The first is training, and the second is education. Almost anyone can memorize a one-two-three step formula and, armed with that formula, make a reasonably good portrait. An educated photographer, backed up by experience, brutal self-examination and practice, practice, practice, will learn how, when necessary, to make the steps up as he goes along. Through this process he will learn to produce more exciting photographs. Our goal is to help you become an educated photographer.

How do we plan to do this? First, through a not-exactly-formal textbook approach consisting of written instructions, illustrative photographs and diagrams, and second, through looking at photographs selected from my forty-plus years of portrait photography. Each of these portraits will illustrate and reinforce points made earlier in this book.

"There are two ways to learn photography."

I didn't learn photography by watching videos and attending seminars. I learned by reading, by looking at photographs and more than anything else, by taking pictures. I want to do all that I can to help you, but how much you learn is more up to you than anyone else. You need to back up almost everything you read with test sessions and constant practice.

■ Developing Your Personal Concept of Portraiture

What does it mean to develop a personal concept of portraiture? More than anything else it means developing your own way of seeing and relating to people. Years ago, I was advised to enter two of my finest portraits in the unclassified category at a professional competition. One was a photograph of three sisters. The other was a photograph of two dancers. I was told that my photographs were worth entering, but they weren't portraits. I guess my concept of portraiture didn't mesh with the established idea of what a portrait should be.

Earlier this year, at a Professional Photographers of America sanctioned print salon, I overheard two photographers talking about the judging. One said that an entry of hers, a photograph of a child, was scored down because the judges said it wasn't a portrait. I guess that some things never change.

This brought to my mind a question that I had been asking for almost two decades. What is a portrait? I checked several dictionaries. The most universal definition is quite simple. A portrait is a drawing, painting or photograph of a person, especially of his face. Another dictionary defined a portrait as a likeness of a person. A more complex definition is that a portrait is a description of a person. No definition I found in any dictionary fit into the rather rigid definition I learned, as an old friend used to say in his always irreverent way, "groveling at the feet of the masters."

I like the simplicity of the idea that a portrait is a "likeness of a person." It cuts through all the rule book static and leaves us free to ask the real question, "What is a good portrait?"

I also like the idea of a portrait as description. It's a little more complicated, but this definition invites your imagination to reach beyond the obvious. A perfect, though extreme, example of a portrait as description is the Philippe Halsman photograph of Sir Winston Churchill seated on the bank of a pond on his estate. Churchill's back was toward the camera, but at that time in history, the photograph which emphasized his bulk and his seemingly immov-

"... my concept of portraiture didn't mesh with the established idea..."

able quality, described the man who was one of the free world's greatest leaders during the World War II years.

If you look beyond photographic technique and rule-book composition in your study of portraiture, you'll find many other examples of portraits that go beyond likeness and move toward the idea of a portrait as description.

Halsman, who has been one of my photographic heroes for as long as I can remember, did not set out to define portraiture, but he did express the highest goal a portraitist can hope to achieve. He said that a great portrait should capture the "inner essence" of the subject. This is a tough goal, but it is one we should strive to achieve.

It is good to attend lectures and seminars, to take part in professional organizations and to participate in professional competitions, particularly early in your career, but if you want to develop your own concept of portraiture, please don't rule out other ways of learning.

One of the best ways to learn portraiture is to look at great portraits. There are books that contain collections of portraits which are quite different from the work you will see at a professional print competition. Invest in a few of these books and study the works they contain. Look at collections of portraits by Halsman, Yosuf Karsh, Arnold Newman and at least one collection of the works of the Hollywood photographers of the 20s through the 40s. In addition, there are other photographers who aren't primarily portraitists whose portraiture may add another dimension to the way you think about portraiture. Of these, Richard Avedon and Irving Penn are the first that come to mind.

Don't limit your study to portraiture. Study good photography wherever you find it. One of the most progressive eras in photography was the time period between the two World Wars. I saw a museum exhibition of work by photographers of that time. If I wanted to dramatize my feelings about tghe exhibit, I might say, "In those days, giants walked the earth." The work I saw there was a tribute, not only to the photographers' skills, but to the remarkable sense of perception which they possessed.

Part of the education of every photographer should be to study the work of Paul Strand, Edward Weston, Alfred

Author's Note

Perhaps you wonder what happened to the two non-portrait, portraits I entered in that competition years ago. The advice I got was good. I entered the two photographs in the unclassified category. Both prints were accepted for hanging in the salon and one went into the association's permanent loan collection. You'll find them in Chapter 7 of this book, where I share examples of my work – the product of my personal concept of portraiture.

Steiglitz, Ansel Adams, Edward Steichen and Josef Sudek among others. At first, you may not get the point. I am a great Paul Strand fan, but I remember seeing his work for the first time and asking myself, "What's so great about this?" I heard so much about Strand from so many people whom I really respected that I stayed with it. One day a light came on. I never could figure out exactly what it was, but there was something there and it rang my bell. It still does.

Although your only current photographic interest may be in portraiture or wedding photography, why not put away your golf clubs, choose some area in photography other than what you do for a living, and make it your hobby? Long ago, I embraced the whole miracle of photography. I believe that my photographs of German villages and Dutch fishing boats from the 50s, as well as the almost abstract images of shadows and crumbling walls from the 90s, helped me to form my own personal concept of portrait photography.

"... I embraced the whole miracle of photography."

① Film and Equipment

■ Introduction

This chapter is not intended as an endorsement of any particular film, camera, lights or exposure meter. Instead, it was written to provide an overview of professional films, as well as cameras, lighting equipment and exposure meters that are suitable for studio portrait photography.

All of the major manufacturers of medium format single lens reflex cameras make equipment that is good both mechanically and optically. Instead of choosing by brand, think about the kind of photography you want to do and select equipment that fits your purpose.

■ Choosing a Film

For years, there was no choice of color films for studio portrait photographers. Kodak's Vericolor was it. Today, you can choose from six medium speed films. Four are films that are designed to produce normal color saturation at low to normal contrast. They are Agfa Portrait 160, Fujicolor NPS 160, Kodak Portra 160 NC and Konica Professional 160. Each of these films has a manufacturer's ISO rating of 160. All were designed to produce natural skin tones and moderate color saturation at low to normal contrast. The other two, Kodak's Portra 160 VC and Agfa's Optima Prestige 100, offer more vivid color and higher contrast. A look at natural color and vivid color films, and what they can do for you as a studio portrait photographer, is more significant than a consideration of specific brands.

• **Natural Color Films.** These films are recommended for use under controlled studio conditions. They were designed to produce natural color and a full tonal scale. If the film is exposed and processed properly, you will be

"... think about the kind of photography you want to do..."

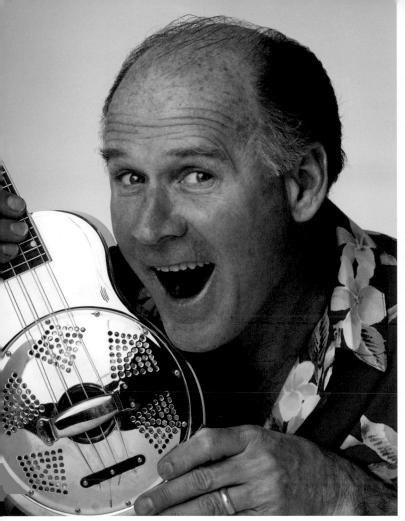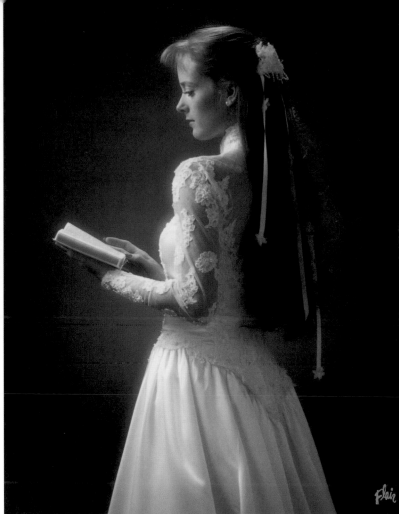

IMAGE 1 IMAGE 2

Image 1. In this portrait, my client (an entertainer on the cruise ship circuit) wanted to communicate the idea that his music/comedy show is a bright and happy act. Kodak's Portra VC, with its higher color saturation and contrast, is the perfect film to capture a subject such as this. **Image 2.** *It can be hard to hold detail in a bride's white dress. Films like Kodak's Portra 160 NC, Fuji NPS 160, Agfa Portrait 160 and Konica Professional 160 were designed to maintain detail at both dark and light extremes better than enhanced color films.*

able to record detail over the full tonal range from detailed whites to the darkest grays. A film of this type is indicated anytime good detail in areas with darker tones is required.

• **Enhanced Color Films.** According to Kodak's web site, their Portra 160 VC is not recommended for studio portraiture except in the specialty of glamour photography. Actually, it is much more useful than that. For example, a heavy diffusion filter reduces contrast dramatically. Choosing a film like 160 VC will help to maintain more normal contrast whenever one of these filters is used. A brightly lit white background plays havoc with contrast in a small studio. Using a film such as VC can maintain that contrast. VC is a good choice anytime you want exceptionally clean whites, such as backgrounds in high key photography. In fact, an enhanced color film can be used for portraiture anytime more brilliant color is required.

• **Personal Exposure Index (PEI).** The manufacturer's rated speed of all of the films listed, except Agfa's Optima Prestige 100, is 160. Is this the true speed? Kodak tells us that, as far as their Portra films are concerned, we can give up the search for the best possible exposure index and use the box speed. However, some lab professionals still say that it is a good idea to run your own tests, using your own equipment to determine your own personal exposure index (PEI). This makes sense. Regardless of any considerations concerning the film, cameras, lights and exposure meters aren't equal.

If you would like to run your own tests follow this procedure:

1. Copy the film test form in the back of this book or design one of your own. Keep careful records, not just of exposures, but of anything that may impact the density reading of your negatives. Don't use a diffusion filter or shoot on a white background for this initial film speed test.

2. Set up your lighting using a main, fill and background light (see Chapter 2 for more information on lighting).

3. Take a careful incident light reading (see the section called "Exposure Meters" later in this chapter).

4. Make your first exposure at one stop less than the meter reading. Open your lens a half stop and make another exposure. Make your next exposure at the aperture you got when you read your meter. Next add a half stop. On your fifth shot, make an exposure one stop greater than your reading. If you have a standard 18% gray card, ask your subject to hold it over his face and repeat the exposure series.

When you send your film in for processing, ask for densitometer readings as well as the usual density numbers. Ask your lab to match the density of every print in each series as

Densitometer Readings

Both lab density readings and densitometer readings are used to determine the density of your negative. Most labs provide a density reading of each negative that they proof. These readings are very useful in tracking the accuracy of your exposures. Just compare the density reading that you should find on the back of your proof, on the negative envelope, or on a separate print out, with the normal density reading which your lab will provide. Lab density readings vary depending on the type of system that is used.

Densitometer readings are standardized and are most useful when running precise exposure tests. The normal reading can be obtained from the film manufacturer in the form of data sheets or, in some cases, on the company's web site. For example I found the recommended density ranges for all four of Kodak's Portra films by going to Kodak.com and tracking my way through professional products to "Judging Negative Exposures." Don't compare the routine density readings from your lab with the norm for densitometer readings. They aren't the same thing.

Professional color labs don't routinely provide densitometer readings. You will have to request them.

closely as possible. The gray card match is simple, because a gray card is a known standard. The people prints are harder for the lab, but if this test is to be of any value, the front of the face must match in tone throughout the series and must conform to the standard you set.

Pick the best print from each series. Check your test records. Which negative produced the print you like best? That is the one that will determine your PEI. Check its density reading. This will be the standard you'll shoot for in your day to day work.

If your best print is from the negative that was made at ISO 160, then 160 will be your PEI. If your best print was made from a negative that received a stop more exposure, your PEI will be 80. If it falls at the in-between mark, your PEI will be 125. You may not see much difference in your test prints because the exposure latitude of modern films is wide. If this is the case, choose the negative with the density reading that is closest to the density your lab prefers.

Make it a practice to monitor the negative density readings that most labs furnish with your proof prints, but don't get caught up in a numbers game. The latitude of today's color negative films is remarkable. You will find that you will get excellent results over a wider range of exposures than before.

• **Processing.** Proper processing is as important as the film you choose. Although most labs work to a very similar standard, and many subscribe to the same monitoring programs, you may find differences between the work of one lab and another in both density numbers and the appearance of your photographs. Tests show up to a 1-1/2 stop density difference between identically exposed negatives that were processed by two different labs. If you run into a situation such as this, talk to people at both labs because someone has a problem and you can't afford to let it become your problem.

• **Choosing a Color Lab.** One way to choose a color lab is to try several. Expose one roll of film identically for each lab. Have the film processed and proofed. Compare the prints. The lab that makes the best proofs is the logical choice for further consideration. Why is the job they do on proofing so important? First of all, the proofs you present to your customers make the strongest impression you'll have a chance to make until the final prints are made. Their quality may have a direct effect on the order you get. Second, proof sales can add substantially to your profits. Finally, your proofs are your first chance to evaluate

"...monitor the negative density readings..."

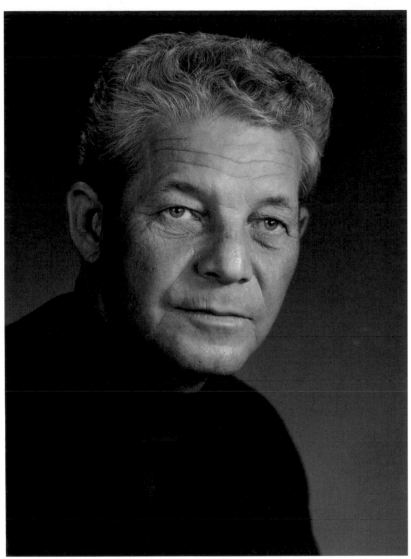

IMAGE 3

One of the reasons for the revival of interest in black & white photography is its longevity. Not only do the prints last longer, but so do the negatives. This print was made from a negative that is over thirty years old. Many color negatives that are much younger have already faded to the point that high quality prints cannot be made from them.

your own work. It's hard to make an accurate evaluation from a bad set of previews.

•**Black & White Films.** Don't forget black and white. Once again you should choose a medium speed film. Kodak and Ilford each offer two. Kodak's Plus X Professional and Ilford's FP-4 Plus are conventional films, made using the same film-building technology that has been around for years. Ilford's Delta 100 Professional and Kodak's T-Max 100 are new generation films, featuring new grain technologies, and improved sharpness. Plus X Pan and FP-4 Plus both have an ISO index of 125, while the two new technology films have an ISO of 100.

Because of the investment in equipment that is required to produce color portraits efficiently, it is usually more practical to leave the processing to a good outside color laboratory. The beauty of black and white is that it is refreshingly low tech. Printing your own is the perfect do-it-yourself photographic project. All you need, other than basic darkroom equipment, is the desire to see the best possible print from your negative.

• **Polaroid Test Film.** A Polaroid back, loaded with either Polapan Pro 100 or Polacolor Pro 100, is a valuable learning tool. Because there is a difference between the way color negative films and Polaroid color films record colors, you may find black and white to be just as good for test purposes. Kodak says that, because of the wide latitude of their Portra films, you can use the same exposure that you used for your Polaroid tests and still be well within the latitude of the film. The same is true for Fujicolor NPS 160 and probably any other natural color film

• **The Author's Choice.** A lot of my current work is portraiture of children on a white background. When I shoot on white, I want clean looking backgrounds. I also want to overcome the degrading effect on color that light bouncing off the background (and around my rather small studio) can have on colors. I used to solve both of these

problems by using Kodak's Pro 100, which was Kodak's enhanced color film before the days of Portra. When Portra VC 160 was introduced, I made the switch and am happy with the new film. I get the same clean backgrounds and colors with the advantage of a little more speed than I got when using Pro 100.

My choice of a film for medium and low key portraiture is not as clear cut. As far as I am concerned, a good film for this purpose should record a full range of tones. Both Kodak's Portra 160 and Fuji's NPS 160 will record detail in a businessman's black coat or a bride's white dress, if they are exposed and processed properly. At this point, I am not sure which does the job best. I do know that neither gives me the results I wanted when used at the manufacturer's recommended film speed.

■ Camera Selection

• **Medium Format Cameras.** A medium format single lens reflex camera (SLR) is the standard for professional portrait photographers. Although all medium format cameras use 120 size film, they don't all make the same size negatives. You can choose between a camera that makes 6x6cm negatives or one of the "ideal format" cameras that makes negatives that are directly proportionate to 8"x10", the most popular print ratio. Your choice will depend in part on your style of photography. If you want to pre-plan your images on the focusing screen without having to do any mental cropping, you may prefer a camera that makes a 6x7cm or 6x4.5cm negative. If you favor a spontaneous style of portraiture, you will appreciate the advantages of the square negative that allows you to shoot square and leave the final cropping until the prints are made.

All of the major, medium format SLRs offer excellent optics and are good mechanically. The factors that should influence you most are the special features that differentiate the brands and models. For example, a motor drive will allow you to move away from the camera, attract your subject's attention, shoot and move and shoot again without going back to the camera. A motor drive, which is useful during any portrait session, is great if your style is spontaneous and is even more desirable when photographing lively children. Autofocus is just coming to medium format photography. When it has wider availability, it may prove almost as essential as a motor drive to many photographers.

Your choice of lenses is at least as important as your choice of cameras. Unless your studio is gigantic, you will need a bare minimum of two: a long focal length lens for

"Your choice will depend in part on your style..."

This certainly isn't a traditional portrait. It was made as an ad illustration. Although you can capture photographs like this using almost any camera, it is easier if your camera is quick and responsive. I used a Hasselblad EL with a long release cord to make this photograph. Once everything was in place and the jump area defined, all I had to do was shoot again and again. The job was harder for my model – she had to jump again and again!

IMAGE 4

head and shoulders portraits, and a lens of normal focal length for full length portraits and group photography. If you like to shoot soft, you'll find prime soft focus lenses for several of the medium format cameras. If a soft lens isn't available for your camera, you can always turn to diffusion filters which are covered in Chapter 5.

• **35mm Cameras.** What about 35mm? If you aren't a pro and just want to make better photographs of family and friends, one of the modern 35mm autofocus cameras is a good choice. A wide range of lenses, including affordable zoom lenses, is available for every quality 35mm camera.

• **The Author's Choice.** My first medium format, single lens reflex was a Hasselblad 500C, which was the only SLR with a between-the-lens shutter that was available at the time. Hasselblad hasn't done anything wrong enough, and their competition hasn't done anything enough better, to make me want to change. At that time there was no consideration of choosing between a 6x6cm and an "ideal format" SLR. There were no 6x7cm or 6x4.5cm cameras.

A few years later I bought a 500EL, the camera that I still use for my studio portrait photography. Perhaps the EL's motor drive, coupled with the convenience of the Hasselblad's square negative, influenced the style I developed. I don't really know. I do know that the responsiveness of the system fit into the photographic goals I set for myself. I use three different lenses, an 80mm normal lens, a 150mm long focus and a second, slightly shorter, 120mm lens.

■ Exposure Meters

There are two basic types of exposure meters. The first is a reflected light meter which reads the amount of light reflected from the subject to the lens of the camera, and the second is an incident light meter which reads the amount of light that falls on the subject. An incident light meter is the meter of choice for studio portrait photography. (See Chapter 3 for more on this topic.)

If you work with studio electronic flash, as almost all portrait professionals do, your meter must be capable of reading the burst of light from your strobe system. In the past, flash meters were either very basic or excessively complex. Many of the earlier flash meters were also very specialized meters that could only be used to read

a burst of light. Today's meters are loaded with features but are still very easy to use. Modern meters are also versatile instruments, capable of reading ambient light as well as the illumination from a flash unit. Some meters read a combination of both flash and ambient light and will calculate the relative intensity of each as well as an exposure that considers both. With the proper adapter, a good meter reads both reflected and incident light and can also be adapted to work as a spot meter. A spot meter, which is a reflected light meter that reads a smaller area of your subject, can be useful when you move beyond the confines of your studio, but has limited application in studio portraiture.

- **Incident Meters.** All exposure meters work toward the same standard. They are designed to read a scene, then calculate the exposure required to record a middle gray at its proper tonal value. Since reflected light meters have only limited usefulness in studio portrait photography, we will not discuss the theory of reflected light readings in this book. Instead we will think about incident meters, how they work and how to choose the one that is best for you.

Because an incident light meter reads the amount of light falling on your subject rather than the amount reflected from it, the tonal value of the subject will not affect your exposure reading. On the surface, this might seem completely wrong. In fact, an incident light reading is best for studio portrait photography. If an incident light reading is correct for a middle gray subject, it is also correct for a subject of any tonal value.

The following exercise may help you understand how this principle works. Go to your professional photographic stock house and buy a package of two 8"x10" Kodak neutral density gray cards. One side of each card is middle gray, the other is white. Buy an 8"x10" piece of flat black mat board also. Set the three up, side by side, in an area of even light. Take an incident light reading with the meter positioned in front of each card. If all three cards are in the same light, and if you position your meter the same in relationship to each card, all three readings will be the same. When you use that exposure reading, all three cards will be record-

Metering Terms to Know

- **Incident Light Meters** measure the amount of light falling on a subject. An incident light meter is the best type of meter for studio portrait photography.
- **Reflected Light Meters** measure the amount of light reflected from the subject. They aren't as useful for studio portrait photography.
- **Middle Gray** is the tone that is the aim point for all exposure meters.

"All exposure meters work toward the same standard."

Dome vs. Flat Disk

The dome shaped diffuser, which is standard with every incident light meter, collects light from above, below and to each side and averages that light to provide its reading. A flat disk reads only the light that falls on its flat surface, making it easier to calculate the effect of each light separately. The dome shaped diffuser is good for general exposure readings, while the flat disk is much better when calculating lighting ratios. If you use the dome shaped diffuser to take your final exposure reading, be careful to shield it from the effect of a hair light or other accent lights, which should not be part of the exposure calculation.

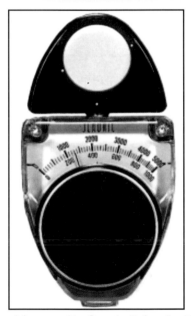 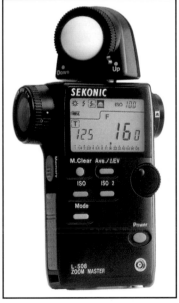

Above, Left. *A Sekonic L-246 incident meter with a flat disk.* **Above, Right.** *A Sekonic L-508 incident meter with a dome receptor. Photos by Sekonic.*

ed at their true tonality. (You can read more about true tonality in Chapter 3.)

Which meter should you buy? Brand name isn't nearly as important as the features and functions offered. The better flash meters perform a number of functions, some that you will use in studio photography, and some that are more useful in other situations. Since very few photographers do just one kind of work, consider the features offered and pick the one that you think will fill your future needs as well as your current needs.

Watch out for meters with small incident light receptors. These meters were probably designed primarily as reflected light meters and may not work as well in the incident mode as meters with full size receptors. Pick a meter that allows you to switch from a dome shaped receptor to a flat disk, or to a reflected light attachment. The flat disk diffuser is almost essential, since it provides the most accurate readings when calculating lighting ratios, as well as more accurate exposures in many situations. Select a meter that has an analogue scale as well as a digital scale because many of the special functions read out directly on the analog scale.

If possible, evaluate several different meters. They are like little computers designed to provide a great deal of exposure data. For example, you can store your reading in the meter's memory bank, then you can take one reading and, from that reading, calculate the relative amount of ambient light and flash that illuminates the scene. You can use the meter's memory function to calculate the difference in f-stops between the keylight and other lights in the system. (See Chapter 3 for more on this topic.) Study the features offered by several different meters. Choose the meter that fits in with your goals in portrait photography.

• **Author's Choice.** I use a Minolta Flash Meter IV. It's not Minolta's latest and I don't care. It does a number of jobs for me and does all of them well. Before I bought the Flash Meter IV, I used it's predecessor, the Flash Meter III and before that, the original Minolta Flash Meter. I replaced

the first two only when I was convinced that the new models offered features that I believed would be useful to me. I haven't found anything in the newer models that seems significant enough to warrant another change.

■ Lighting Equipment

Two basic types of studio electronic flash units are available: monolights which are self contained units that include their own power supplies, and box and cable systems which consist of a power pack that supplies power to two or more lampheads.

• **Monolights.** It is easy to regulate light intensity between monolights because each has its own power supply. The main disadvantage in a monolight system is cost. Every time you buy a new monolight, you are buying another power supply, as well as another lamphead. A second disadvantage is weight. A monolight is hard to rig on a boom when you need to use it as a hair light or other overhead light. On the other hand, monolights are easy to pack and easy to set up on location, and eliminate the tangle of connecting cables.

• **Box and Cable System.** You'll get more light per dollar spent if you choose a box and cable system. However, you may find controlling light intensity and ratios to be harder. The least expensive box and cable systems feature a symmetrical light arrangement which distributes an equal amount of light to each lamp head. This makes it harder to control the intensity of each light independently.

To light a portrait successfully, using a symmetrical lighting system, you have to make your system distribute light asymmetrically. In other words, you must make it deliver the proper amount of light to each area within the photograph, rather than a uniform amount of light over every area. You can do this by moving the light closer to or further from the subject, by covering it with lighting-grade neutral density filtration material, or with one or more layers of diffusion material. However, the best way to make a symmetrical system perform like an asymmetrical system is to use different types of light modifiers on your keylight and your fill light.

For example, you can use a silver or zebra umbrella as a keylight and a white umbrella as a fill. Even though each lamphead emits the same amount of light, the quantity that reaches the subject will be different. You can also use a parabolic reflector on your keylight and an umbrella or soft

"... monolights are easy to pack and easy to set up on location..."

Types of Umbrellas

Each type of umbrella produces a different lighting effect. A bright silver umbrella casts shadows that are sharply defined while a soft white umbrella casts softer shadows, and a zebra umbrella, with its alternating panels of silver (or gold) and white, produces an in between effect.

box on your fill. There is one solution that doesn't work: don't connect a power variation box to one of your lights. Even though it's plugged into just one power outlet, it still reduces the amount of light going to the whole system.

• **Asymmetrical Lighting Systems.** Banks of capacitors in an asymmetrical system are isolated, allowing you to reduce the amount of power that goes to each group of capacitors independently. If you need a finer degree of control, you can add a power control box such as the LiteLight Variator to one or more outlets.

•**Power and Recycling Times.** Portrait photography doesn't require as much light as some types of commercial photography. However, it is important to have enough light where and when you need it. How much do you need? Strobe power is rated in watt seconds and in b.c.p.s. (beam candle power seconds). Don't spend too much time thinking about either system. Instead think about what f-stop an electronic flash system will allow you to use in your typical portrait set-up. At the very least, you should have enough power to stop down to a minimum of f8 with enough power left over to cover those times when your set-up isn't typical.

Another factor to consider is how long it takes for the unit to recycle between exposures. If your style is spontaneous, you'll need lights that recycle quickly. If your style is more studied, you can use lights with a longer recycling time.

• **The Author's Choice.** My choice is a combination of monolights and box and cable units. Over the years, the work I've done has been varied. A lot of it has been fast moving sessions with active children or models who are moving endlessly. My lights recycle quickly enough to shoot a second time almost as quickly as my motor-driven Hasselblad advances the film and cocks the shutter. I have enough power to be able to stop my lens down to f22 if I need extra depth of field, or if I use some optical device that reduces the amount of light that reaches the film.

"If your style is spontaneous, you'll need lights that recycle quickly."

■ Light Modifiers

While a studio electronic flash system is the standard in almost every portrait studio, there is no standard concerning the ways photographers use their systems. The first electronic flash units weren't all that different from the tungsten lights they replaced. All had parabolic reflectors. Electronic flash units still come from the factory equipped with a parabolic reflector. Sometimes these reflectors are built into the lamphead and sometimes they are removable. Even those that feature built-in reflectors usually have a way to adapt a larger reflector.

In the sixties, the first collapsible soft light source, the photographic umbrella, made its appearance. Umbrellas, which actually date back to the 1800s, caught on quickly. The soft box wasn't far behind. The defining differences between an umbrella or soft box and a parabolic reflector are: the spread of light; its intensity, and its shadow edge characteristic.

In general, a parabolic reflector doesn't spread light quite as evenly as an umbrella or soft box. Because light from an umbrella or soft box either bounces off a surface or is diffused through one or more layers of diffusion material, this light is less intense.

As far as photographic effect is concerned, the edge shadow characteristic of a light source is just as important. Edge shadow characteristics refers to the sharpness of shadows cast by a light source. The two photographs on the opposite page demonstrate the difference. Image 6 was made using a light equipped with a 16" parabolic reflector. This created harder shadow characteristics on the model's face. Image 5 was made using a large, soft light source, which created softer edge shadow characteristics.

• **Parabolic Reflector.** The defining characteristics of a parabolic reflector are the material they are made of and the effect they produce. They are made of metal and they produce shadows with sharp edges unless they are modified.

The effect can be modified by adding a deflector that fits over the end of the flash tube and blocks direct light from the end of the flashtube, thus reducing the danger of

Terms to Know

• **Edge shadow characteristics** refer to the sharpness of shadows cast by a light source. For example, a point light source such as the sun casts shadows that are sharp and distinct. Light coming from the sky on an overcast day casts shadows that are very soft and much less defined.

• **A shower cap diffuser** is a diffuser made of fabric that fits over a parabolic reflector and, like a real shower cap, is held in place by an elastic band.

• **Barndoors** are light blockers that are attached to a parabolic reflector. They can be adjusted to reduce the spread of light.

• **A parabolic reflector** offers more controls and a somewhat wider range of effects than other light sources.

"... a parabolic reflector doesn't spread light quite as evenly..."

hot spots. For a softer effect, a shower cap diffuser which fits over the rim of the reflector can be added. The area covered by the light can be modified by using barn doors.

•**Umbrellas.** Umbrellas were the first modifiers designed to soften the effect of photographic lighting. To a large degree, their more sophisticated cousin, the soft box, has stolen the umbrella's thunder, but an umbrella still has certain advantages. Although there have been improvements in the way the newest soft boxes set up, an umbrella is still the choice when fast set up and break down is important. Umbrellas come in a variety of fabrics, ranging from soft white to bright silver, and include zebra umbrellas with panels that alternate between silver and white. Some feature interchangeable fabrics, which makes it possible to change

Image 5: *A soft light source, such as a large white umbrella, casts shadows with soft edges.* **Image 6:** *A parabolic reflector with a metallic finish casts harder shadows.*

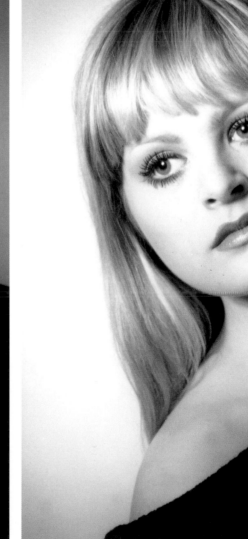

IMAGE 5

IMAGE 6

effects even if you only have one umbrella. Umbrellas are also available in a variety of sizes, making it possible to produce an effect ranging from a true "wrap-around" light, to light very much like light from a parabolic reflector.

This combination of sizes and fabrics makes a variety of effects possible. For example, Image 7 (below) was made using a 32" Larson Hex umbrella with a bright silver fabric. Look at the nose shadow. There is a darker shadow within the main shadow. This was not caused by a second light. Instead, it is the product of an umbrella that was placed too far from the subject for its size.

Image 8 (below), which is much softer than the preceding photograph, was made using a very different umbrella, a Balcar 60" Zebra. Its softness was caused, in part, by the

Terms to Know

- **Wrap-Around Lighting.** This lighting term is so descriptive that it almost defines itself. In portraiture, a wrap-around light illuminates both the highlight and the shadow side of the subject's face, though not necessarily uniformly. See the section entitled "The Wrap-Around Effect" in the next chapter.)

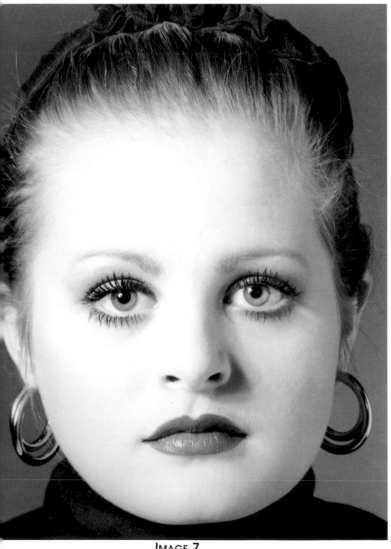

IMAGE 7

IMAGE 8

difference in fabrics, but the main difference is in the size of the umbrella. It was large enough and was placed close enough to the subject to produce the wrap-around effect that is a characteristic of large umbrellas.

Some photographers complain that the umbrella's ribs create objectionable shadows within the catch lights of the subject's eyes. New umbrella designs eliminate this problem by extending the interior fabric to cover the umbrella's ribs. Image 9 (below) was made with one of these umbrella – an Eclipse lined with soft white fabric.

You can choose between a conventional round umbrella or a square. A square umbrella can be adjusted from a flat surface, which produces softer spread of light, to a concave surface which produces a somewhat more concentrated light pattern. Most round umbrellas don't offer this kind of adjustment. Another difference between round and square umbrellas is the difference in the shape of the catch lights in the subject's eyes.

IMAGE 9

Image 7: The multiple shadows under the subject's nose were caused by a small umbrella placed too far from the subject. **Image 8:** *Using a large umbrella and placing it closer to the subject creates a softer effect.* **Image 9:** *To keep the umbrella's ribs from showing in the catchlights in the eye, select an umbrella lined with fabric to cover the ribs.*

• **Soft Boxes.** Soft boxes come in a variety of sizes and shapes. The four photographs shown here were made with a collection of large light modifiers. Image 10 was made using a unique light modifier, the Westcott Airbank™, which is a cylindrical, air supported light source. The spread of light is adjustable from a strip light effect to a 140° spread. Image 11 was made using a 50″ square Westcott Apollo JS. This soft box has a recessed face that makes it possible to cut light off more sharply than a flat face box of the same size. However, its large size also makes it easy to create wrap-around lighting.

Large soft boxes, like large umbrellas, can be used to create wrap-around lighting even when photographing a full length subject. Image 12 was made using a 72″ Larson Starfish as the keylight, and a reflector as the fill. Image 13 was made using a Larson 4′x6′ soft box. The distribution of light from this soft box is very efficient because it is fitted with a speed ring which allows a photographer to position

Image 10: This portrait was made using a unique light modifier, the Westcott Airbank™, which is a cylindrical, air supported light source.
Image 11: This photograph was made using a 50″ square Westcott Apollo JS, a soft box with a recessed face that makes it possible to cut light off more sharply than a flat-face box of the same size.

IMAGE 10

IMAGE 11

it in a vertical position when the subject is vertical, and to spin it into a horizontal position when the subject is horizontal, as this one is.

Smaller soft boxes produce the same wrap-around effect when placed close to small subjects, or an effect more like a parabolic reflector when used further from the subject. The two main classifications of soft boxes have to do with the shape of the boxes' faces. The first soft boxes had flat faces. One of their characteristics was that they restricted the spread of light more than an umbrella. Newer designs feature recessed faces which extend the degree of control even more.

Soft boxes with rounded or protruding faces are completely different. They are designed to spread light more evenly and to allow the photographer to direct more light toward the ceiling, walls or floor when needed. They are also available in a variety of sizes, with the larger sizes better adapted to creating wrap-around lighting.

• **The Wrap-Around Effect.** Using an umbrella or other soft light modifier does not automatically assure you that you will create wrap-around lighting. The rule of thumb for wrap-around lighting is that you should use a light source that is as big as your subject and place it at a distance from the subject no greater than the diameter of the light modifier. This means that if you want to make a full length portrait of a subject that is six feet tall, you should use an umbrella or soft box that is six feet in height. If you plan to show a smaller area of the subject, a head and shoulders view for example, you can use a smaller light modifier just as long as it is as big as the portion of the subject that will appear in your portrait.

Image 12: *This image was made using a 72" Larson Starfish as the key-light, and a reflector as the fill.* **Image 13:** *This portrait was made using a Larson 4x6 foot soft box.*

IMAGE 14

background

subject

bare flash tube ○

reflector

camera

BARE BULB LIGHTING

DIAGRAM 1

Although this is a valid principle of large light source lighting, don't be too concerned about it in actual practice. If you move your umbrella light back further, what have you done? In effect you've turned your wrap-around light into a light that, although softer, behaves like a parabolic reflector, and what's wrong with that? If it produces the effect you want, who cares whether it is a true wrap-around effect? Remember, in portraiture, the only rule is that, whatever type of lighting you use, you should present your subject in a good light.

• **Bare Bulb Lighting.** Bare bulb lighting is a favorite technique of wedding photographers. However it is an almost undiscovered light source for studio portraiture. To use it, you need to understand what a bare flash tube is and what it does. A bare flash tube isn't a soft light source. Instead, like the sun, a bare bulb is a point light source that

"... you should present your subject in a good light."

casts shadows with very sharp edges. In fact, the edge shadow characteristics of a bare bulb are just as sharp as those produced by an optical spot light. The difference between the two is contrast. While a spot light with no fill produces a high lighting ratio, a bare bulb reflects light from every surface within its 360° range, producing open, detailed shadows. Image 14 was made using a single bare flash tube with a large white reflector placed as shown in Diagram 1. This reflector serves two purposes. First, it blocks light that might reach the lens of the camera and second, it directs fill light back to the subject. In addition, light bouncing from the reflector and light bouncing from light colored walls add a multi-directional fill.

•**Reflectors.** You can create lighting that is just as good as (though different from) the lighting created using the most elaborate systems if you use an umbrella light or a soft box with one or more reflectors, and a second light to illuminate the background when background lighting is needed. When possible, use a reflector that is at least as large as your subject.

If you choose a reflector as your fill light, you must place it just as carefully as you would place a second light. Do not direct it straight into the shadow side of the face as shown in Diagram 2. This will over-illuminate the part of the face that is furthest from the camera and eliminate the fall off of light within the shadows, which helps us create an

"...use a reflector that is at least as large as your subject."

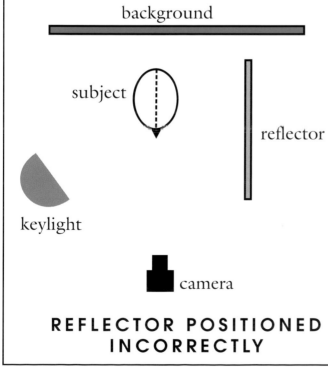

REFLECTOR POSITIONED INCORRECTLY

DIAGRAM 2

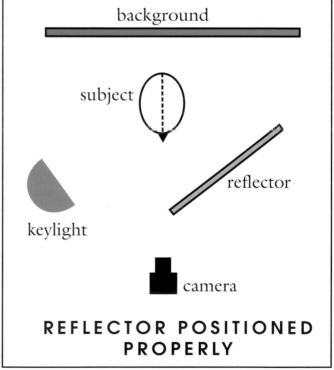

REFLECTOR POSITIONED PROPERLY

DIAGRAM 3

illusion of roundness. Place your reflector as shown in Diagram 3. This will illuminate the part of the shadow side of the face that is closest to the lighted mask of the face more than the shadow area that is further from the front of the face.

If you need additional light in the subject's eyes or under the chin, you can add a second "kick-up" reflector placed low and close to the subject as shown in Diagram 4.

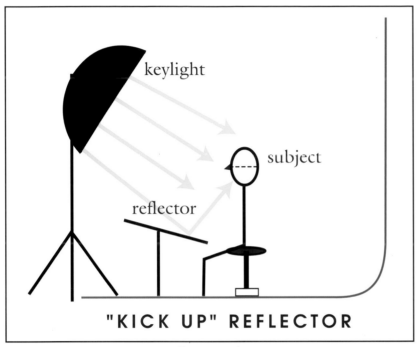

DIAGRAM 4

Once your light and reflectors are in place, look at the reflectors. Are they well illuminated? If they aren't, feather your keylight toward the reflectors until they do receive a satisfactory amount of light. Feathering is a term that may be new to you. It means that, with the keylight in place, you swivel it in either direction, depending on the objective you want to achieve. In this case, the objective is to bounce more light off of the reflectors.

• **Author's Choice.** I don't have strong brand preferences. Each of the major manufacturers has a product that works for me. In my studio I use a 52" Larson Starfish as my keylight when I do full length portraiture on a white background. I also use it anytime I want a light that is soft and spreads more evenly than a standard soft box. I use a Westcott 28" Apollo with a recessed front when I want a little more control. I use a 3'x4' Photoflex Multidome or a 39"x72" Photoflex Litepanel as a fill. I also use the Multidome as a keylight with a reflector as a fill from time to time. I use a Larson Soff Strip fitted with louvers as a

"Once your light and reflectors are in place, look at the reflectors."

hairlight. The bulk of my studio work is done with these lights and lights fitted with 7" parabolic reflectors that I use for background and accent lights.

I use umbrellas on location and occasionally in the studio. I have two 56" Balcar Jumbo umbrellas. One is a soft white and the other is zebra which features alternating panels of white and silver. I have a set of 45" Eclipse umbrellas, one with a silver interior and the other with a white. I like the fact that I can change effects quickly by switching from the Silver Eclipse to the soft white.

My one real preference is for large light sources that can be used to wrap light around my subject when I want that effect. Since my work is varied, I like having a combination of light sources that spread light, such as the Starfish, and those that cut light off more sharply, such as the Apollo.

Images 15 and 16: *If you always make carefully posed portraits, the kind that are successful because every element is carefully arranged, you don't need to be concerned about strobes that recycle quickly. On the other hand, if you enjoy photographing a model in a fast-moving session (or a two year old in an equally fast-moving session), quick recycle times can be the difference between getting shots and missing them.*

IMAGE 15

IMAGE 16

②
Lighting

◼ Introduction

My theory of portrait lighting is simple: if it looks good, it is good. On the other hand, if it looks bad, it is bad. Perhaps it seems strange, after saying that, to go ahead and invest my time and yours in the discussion of keylight placement, using a fill light, etc. I don't think it is. You can't expect to go into the studio, turn on the lights and set up lighting that looks good without having a starting point. Getting to that starting point is what almost everything in this book is all about.

One of my photographic heroes was George Hurrell, one of the great Hollywood portrait photographers who photographed the most famous stars of the 20s, 30s and 40s. Hurrell was famous for his portraits of Hollywood's leading men and women. He was also a rule-breaker. One general rule of lighting is that the center of interest, the subject's face, should receive more light than any other part of the subject. Hurrell didn't always follow this rule – or any other. Sometimes he seemed to place his keylight almost at random, but whatever he did with light, it almost always worked. Find a book that shows his work and study it. His style was quite different from most of the photography you see today. Don't expect to like everything he did (I don't), but look at it with an open mind. You'll see dazzling portraits of the most beautiful women and handsomest men from the glamour years of the movie industry.

> "Hurrell didn't always follow this rule – or any other."

◼ The Keylight or Main Light

Remember the "Looks Good" rule as you work your way through these lessons. Use what you read and see as guidelines. All of the styles of lighting covered here, when

applied to the right face, look good. There is more to lighting than you will find here or in any book. It's important to remember that lighting that looks good doesn't necessarily conform to the rules of classic or traditional portrait lighting. You don't need to lock your lights in to a 3:1 ratio, or follow some archaic rule about one style of lighting being "masculine" and another "feminine." Be as unconventional as you please, but when you are through and are ready to evaluate the work you have done, ask yourself this question: "Does it look good?"

A portrait lighting system usually includes at least two light sources, a keylight and a fill. Other light sources such as background lights and accent lights can be added. The keylight, which is also called the main light, is the dominant light source in a portrait lighting set-up. Therefore, portrait lighting styles are defined by the relationship of the keylight to the mask, or front, of the subject's face. Two factors determine the style of lighting. The first factor is the side of the face toward which the keylight is directed, as shown in Diagram 5.

There are several commonly used lighting set-ups which are named according to the relationship between the keylight and the front of the subject's face. These include:

1. BROAD LIGHTING. To create a broad light, pose your subject to show a 2/3 or 3/4 view of the face and direct your main light toward the side of the face that is closest to the camera. A broad light set-up can be used to add weight to a face that is too thin.

2. SHORT LIGHTING. To create a short light, pose your subject to show a 2/3 or 3/4 view of the face and direct your main light toward the side of the face that is furthest away from the camera. Short light can be used to slenderize a face that is too heavy.

3. FULL FACE LIGHTING. There is no broad or short side to consider when photographing a person who is facing straight into the camera. However, all of the styles of lighting that follow can be applied to a full face portrait.

The second factor that defines lighting style is the relationship between the angle of the keylight and the subject's nose axis.

1. 45° LIGHTING. Direct your keylight toward your subject's face at an angle of approximately 45° to the nose

3/4 FACE SHOWING THE RELATIONSHIP BETWEEN ITS SIDES AND THE LENS AXIS

DIAGRAM 5

axis. You can use 45° degree light from the broad side, or the short side, and to light either a full face, 3/4 view, or profile portrait. The keylight should be placed higher than the subject's head and directed down at an angle of about 45°. One characteristic of 45° lighting is the triangle of light from the keylight that is on the shadow side of the subject's face. 45° lighting is also known as Rembrandt lighting because it is the style of lighting that is seen in many of his paintings.

2. Butterfly or Glamour Lighting. The term, "Butterfly Lighting," comes from a characteristic butterfly-shaped shadow below the subject's nose. If you want to use butterfly lighting, you should line the keylight up along your subject's nose axis and raise the light until you see the charactcristic shadow. This style of lighting is also known as glamour lighting because it was used extensively by the Hollywood portrait photographers of the 20s, 30s and 40s (see George Hurrell on page 30). Although light placement is identical for butterfly and glamour lighting, these photographers gave it a special look by using theatrical spot lights as the keylight rather than a softer light source. You can modify butterfly lighting by moving your keylight a little to the right or left, which will shift the position of the shadow off center.

3. Split lighting. Split lighting divides the face along its center. Split lighting is probably the least used style of portrait lighting, but it can be very effective. To create split lighting place your keylight just as you would for 45° lighting. While watching the patch of light on the shadow side of your subject's face, lower the keylight and move it to the side until the highlight on the shadow side disappears.

The photographs that follow show only one view of the face for each lighting style. You will want to try other combinations. You can use 45° lighting on a full face, or butterfly lighting on a 3/4 view. If it looks good, use it.

The diagrams that are with each photograph show where the keylight was placed, but they don't show any other lights. A fill light was used for all of these photographs. Placement of the fill light will be covered in the next section.

Image 17 and Diagram 6 show an example of 45° lighting from the short side. The keylight was placed just off the nose axis toward the side of the subject's face that is furthest from the camera, creating the shadow on the side of the face that is closest to the camera. This effect can be modified by moving the keylight further to the subject's right or by raising it to lengthen the nose shadow.

"... line the keylight up along your subject's nose axis..."

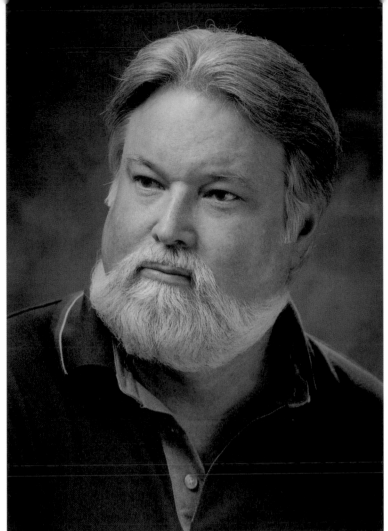

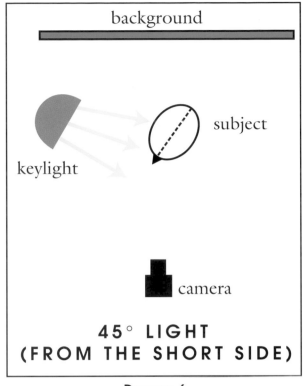

45° LIGHT
(FROM THE SHORT SIDE)

DIAGRAM 6

IMAGE 17

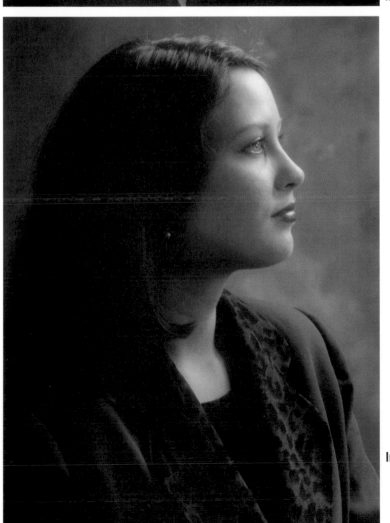

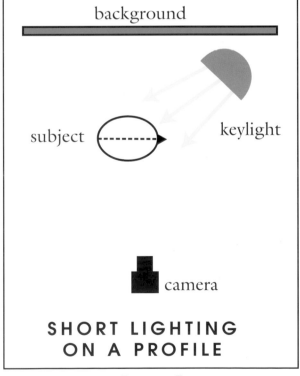

SHORT LIGHTING
ON A PROFILE

DIAGRAM 7

IMAGE 18

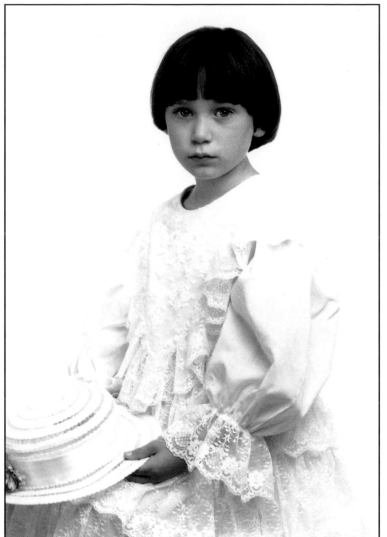

IMAGE 19

background

subject

keylight

camera

45° LIGHT FROM THE BROAD SIDE

DIAGRAM 8

Image 18 and Diagram 7 show another example of 45° lighting from the short side, but this time it is applied to a profile view of the face. The keylight was directed toward the side of the subject's face that was turned away from the camera at an angle of approximately 45°. This style of lighting can be modified by moving the keylight further away from the camera until the nose shadow connects with the shadow on the side of the subject's face. 45° lighting or butterfly lighting is the usual way to light a profile.

Image 19 and Diagram 8 demonstrate 45° lighting from the broad side. The keylight was directed toward the side of the face that is closest to the camera. This effect can be modified by moving the keylight more to either side or by raising it.

Image 20 and Diagram 9 show an example of butterfly lighting on a full face view. The keylight was placed along the subject's nose axis and the height was adjusted to create

"The keylight was directed toward the side of the subject's face..."

34

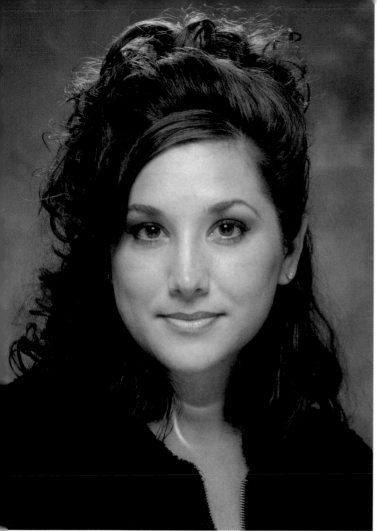

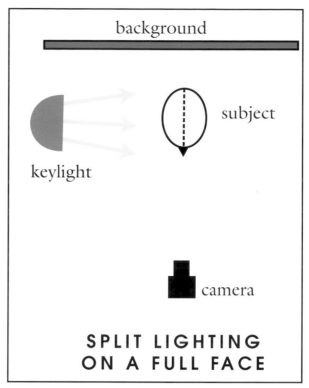

background

keylight

subject

camera

SPLIT LIGHTING ON A FULL FACE

DIAGRAM 9

IMAGE 20

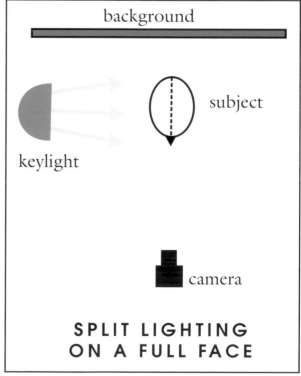

background

keylight

subject

camera

SPLIT LIGHTING ON A FULL FACE

DIAGRAM 10

IMAGE 21

the butterfly shaped nose shadow. This style of lighting can be modified by raising or lowering the keylight. However, if you lower it too much, you will lose the characteristic shadow. Remember, you can use butterfly lighting on a 3/4 or profile view of the face just as well as a full face view. Whatever the angle of the face, just line the keylight up on the nose axis and adjust its height until you see the effect you want.

Image 21 and Diagram 10 show an example of split lighting on a full face. The keylight was placed on the subject's right and moved until the entire left side of the mask of his face was in a shadow. Split lighting is just as effective when it is directed toward a 3/4 view of the face as it is when used on a full face portrait.

■ Fill Light

The purpose of a fill light in portraiture is to add enough illumination to record the degree of detail you desire in the shadow areas of your photograph without creating disturbing shadows that cross each other. In order to accomplish this, you must control the angle as well as the intensity of the fill.

• **Fill Light Intensity.** Before the days of studio electronic flash, portrait photographers used incandescent floods and spot lights for studio lighting. These lights were hot and uncomfortable for the subject, but they had one advantage: they were "what-you-see-is-what-you-get" lights. With a little experience, a photographer could predict lighting effects without metering lights individually.

The almost universal use of electronic flash changed that. A studio flash unit contains two light sources, an electronic flash tube that supplies the light which is used to make the exposure, and one or more incandescent lights

> "... if you lower it too much, you will lose the characteristic shadow."

Terms to Know

• **Modeling Lights.** Modeling lights are components of studio flash units which provide continuous light to guide photographers in setting up their lighting.

• **Light Ratio.** This term describes the difference between the intensity of the keylight and the intensity of the fill light. This is usually written as a ratio, such as 3:1.

called modeling lights. These guide the photographer as he sets up his lighting. Modeling lights don't always tell the whole story. Unless they are perfectly matched to each other and adjusted to the same relative intensity as the flash, they will deceive you. You will need to back up visual evaluations with meter readings, and possibly Polaroid test shots, to be able to predict lighting effects accurately.

Here is how to evaluate the keylight/fill light relationship accurately and to control it properly. First, set up your keylight and your fill and adjust the ratio visually – but don't stop with a visual evaluation. Your eye sees detail that your film cannot record. Once you've made a visual evaluation, go on to a more accurate method. Turn your keylight off and, using an incident light meter, take an exposure reading of the fill light only. Turn on your keylight and aim your meter toward it. With both the keylight and fill light on, take a second reading. Note how many f-stops difference there is between the two readings. This determines the lighting ratio. If your incident meter has a flat disk receptor, use it when taking comparative light readings, because the flat disk reads individual lights more accurately than the standard dome.

"... light bouncing around the room will add an omni-directional fill."

• **The Unseen Fill.** Perhaps the term "unseen" isn't a good description. Maybe "un-placed" is better. No matter what we call it, unless your studio has black walls, ceilings and floors, light bouncing around the room will add an omni-directional fill. This is particularly true when using brightly-lighted white backgrounds in a small studio with white walls. Fortunately, your exposure meter includes this light in its calculations. As long as your walls and ceiling are neutral in color, you don't need to be unduly concerned. Just be aware that it exists and is part of your lighting equation. If your walls and ceilings are painted pea green, for example, the unseen fill will be pea green and you may have a problem.

• **Fill Light Position.** The following photographs demonstrate four different ways that you can use the fill light. Image 22 and Diagram 11 show the effect of a fill light when it is placed on the opposite side of the camera from the keylight. Image 23 and Diagram 12 show the effect of a fill light placed on the same side of the camera as the keylight. Image 24 and Diagram 13 show the effect of a fill light when it is placed along the lens axis. Image 25 and Diagram 14 show the effect of the form fill which is always aimed along the subject's nose axis. The only lights that were used for this series of photographs were the fill light and a background light.

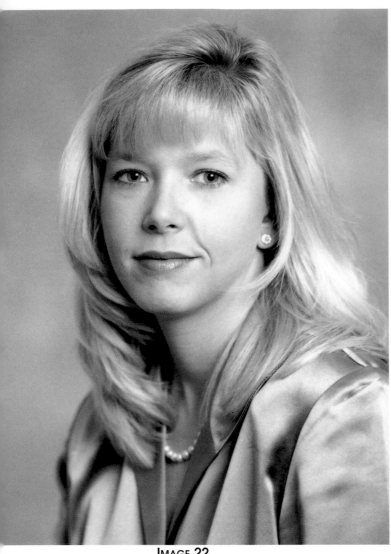

IMAGE 22

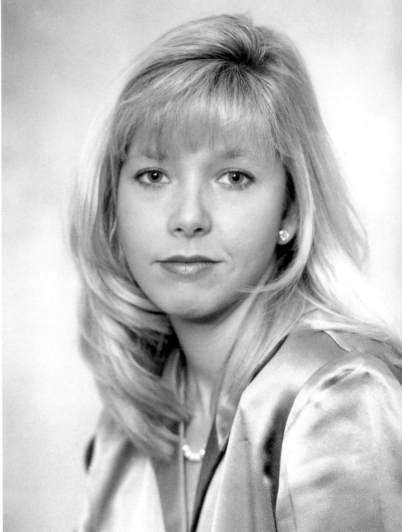

IMAGE 23

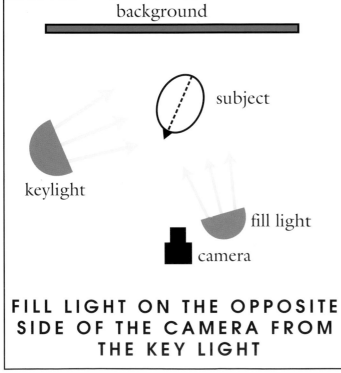

FILL LIGHT ON THE OPPOSITE SIDE OF THE CAMERA FROM THE KEY LIGHT

DIAGRAM 11

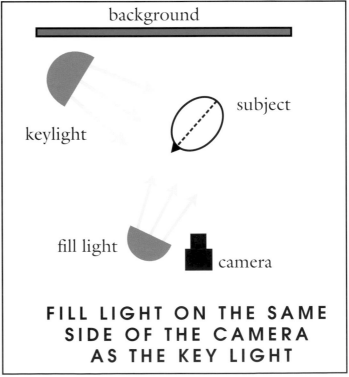

FILL LIGHT ON THE SAME SIDE OF THE CAMERA AS THE KEY LIGHT

DIAGRAM 12

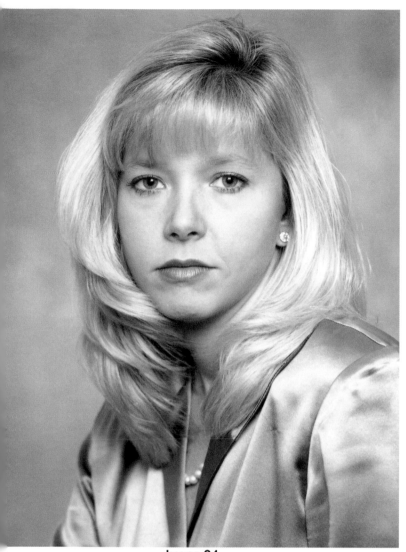

IMAGE 24

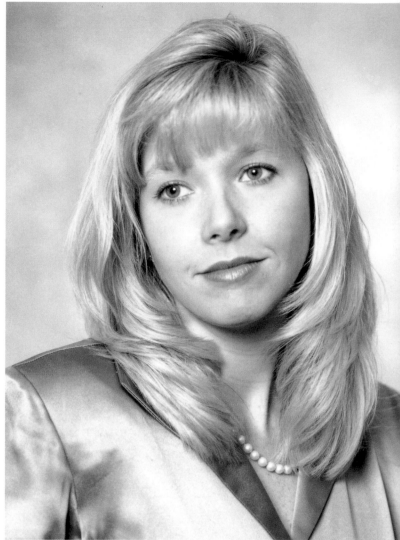

IMAGE 25

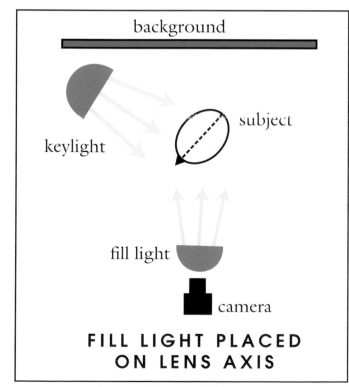

FILL LIGHT PLACED
ON LENS AXIS

DIAGRAM 13

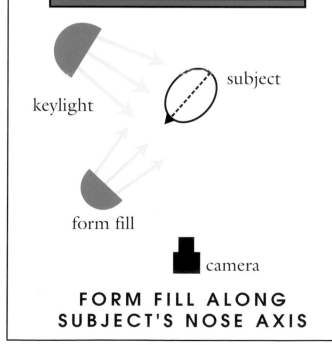

FORM FILL ALONG
SUBJECT'S NOSE AXIS

DIAGRAM 14

The next four photographs show the effect produced when a keylight coming from the short side at an angle of about 45° was added.

Image 26 was made with the fill placed as close to the camera as possible, and on the opposite side of the camera from the keylight.

Image 27 was made with the keylight in the same position. The fill light wasplaced as close to the camera as possible, and on the same side of the camera as the keylight.

Image 28 was made with the keylight in the same position. The fill light was mounted on a boom and positioned along the lens axis.

Image 29 was made with the keylight in the same position. The form fill was lined up with the subject's nose axis. The form fill is more than a fill light. One of the principles of lighting is that light areas advance, or seem closer to the viewer, while dark areas recede, or seem further away. The

Image 26 was made with the fill on the opposite side of the camera from the keylight. Image 27 was made with the fill light on the same side of the camera as the keylight.

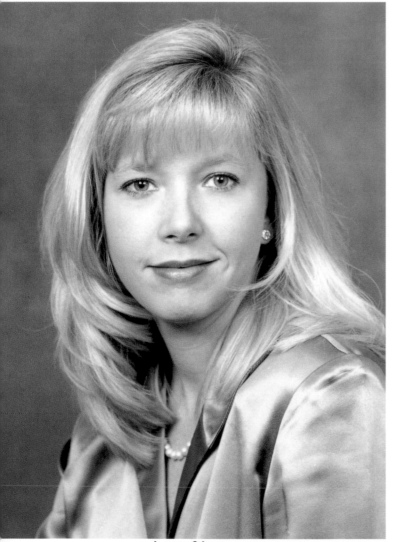

IMAGE 26

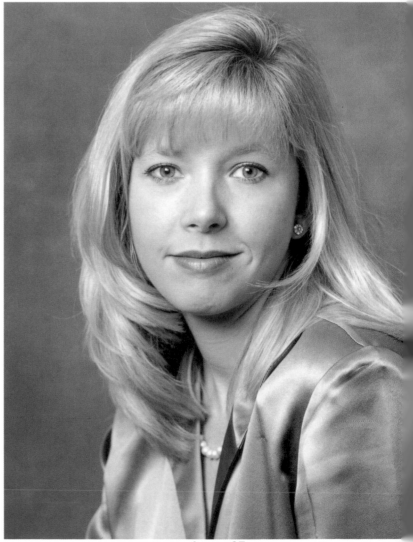

IMAGE 27

IMAGE 28

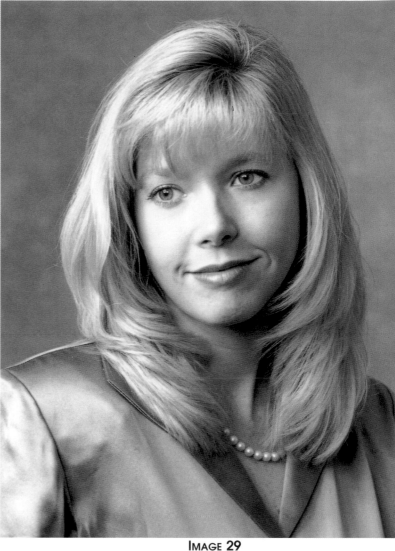

IMAGE 29

Image 28 was made with the fill light mounted on a boom and positioned along the lens axis. Image 29 was made with the form fill lined up with the subject's nose axis.

form fill does not illuminate all shadow areas equally. Instead, it illuminates shadows within, or close to, the mask of the face more than shadows that are further from the mask of the face. This produces an illusion of roundness and depth. Since the position of the form fill is so critical, it is best suited to the classic style of portraiture.

If you find it hard to get the shadow detail you want when using the form fill, you can add an additional light source – either another light or a reflector to provide additional shadow illumination – as long as that light source is weaker than the form fill.

Using your fill light properly is easy if you remember that a fill light should not have character of its own. With the exception of the form fill, all that a fill light is supposed to do is add enough light to shadow areas to record the detail that you want.

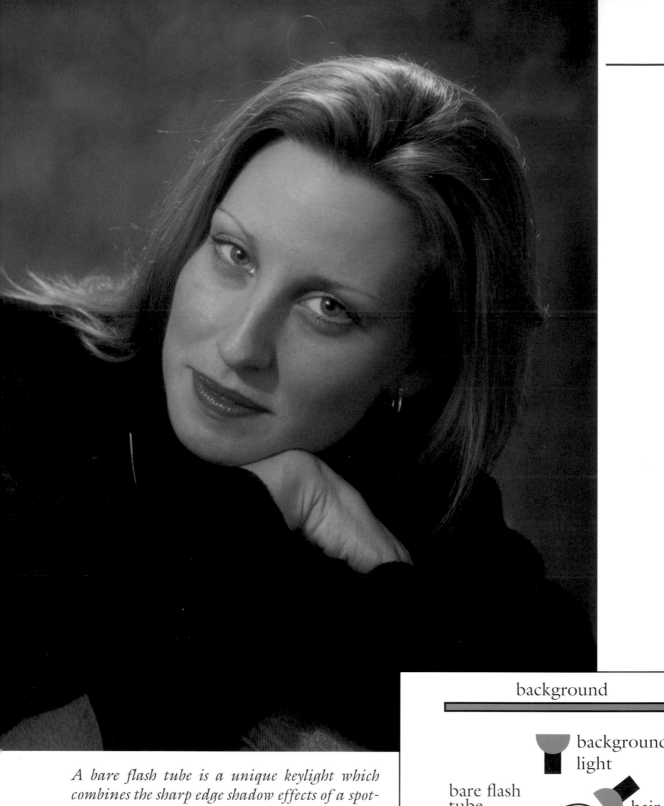

A bare flash tube is a unique keylight which combines the sharp edge shadow effects of a spotlight with the open shadows we usually associate with a softer light source, such as a large umbrella. This is because, in the studio, a bare bulb turns every reflective surface into a source of fill light.

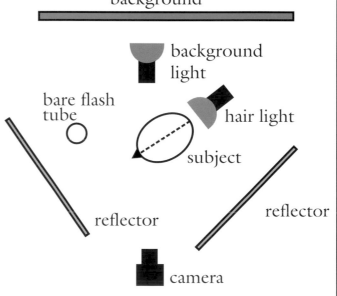

background

background light

bare flash tube

hair light

subject

reflector

reflector

camera

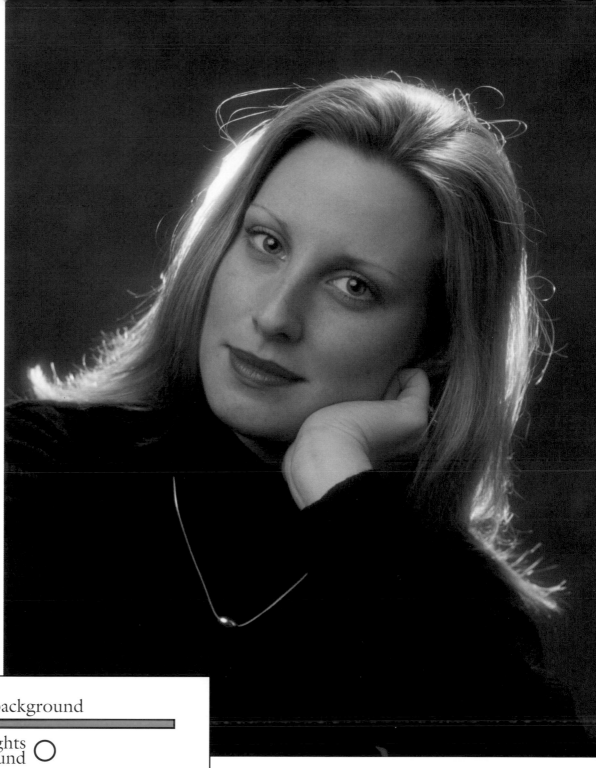

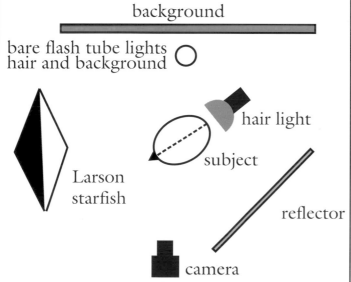

background

bare flash tube lights
hair and background

Larson
starfish

hair light

subject

reflector

camera

The photograph was made using a Larson Starfish as a keylight. This is a soft light source that casts shadows with a soft edge. A Dyna-Lite head, fitted with a grid spot and mounted on a boom, illuminated the top of the subject's hair. A bare strobe tube did double duty by adding a bright accent to her hair while also illuminating the background just enough to record some tonality and color.

■ Lighting the Background

A background light isn't always necessary, but it can be important, because a properly placed background light helps separate the subject from the background. When lighting a background, place your light where it will be hidden from the camera and at a position where it will illuminate the background without spilling onto the subject. For example, you can direct the background light toward the background from behind the subject (Diagram 15), from either side (Diagram 16), or from both sides of the set (Diagram 17).

You can control how light or how dark a background will photograph by adjusting the relationship between the intensity of the background light and the intensity of the light falling on the subject. First, take a reading using an incident light meter from the subject position. If you want the background to photograph in its true tonality, that is, if you want a light gray background to photograph as a light gray, adjust the intensity of the background illumination until your meter reads the same as the subject reading (Image 30). For example, if your reading at the subject position is f8, your background reading should also be f8.

You can create a lighter background by increasing the intensity of the background light. If your exposure reading at the subject position is f8, adjust the amount of light on your background until the meter reads f16, and expose for the subject at f8. Your background will be two stops over-

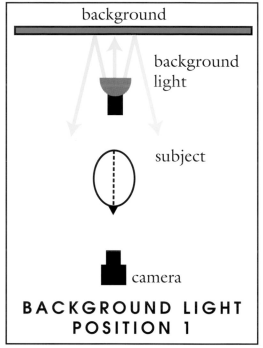

BACKGROUND LIGHT POSITION 1

DIAGRAM 15

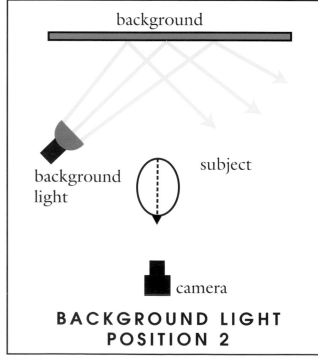

BACKGROUND LIGHT POSITION 2

DIAGRAM 16

BACKGROUND LIGHT POSITION 3

DIAGRAM 17

IMAGE 30

IMAGE 31

IMAGE 32

*In **Image** 30, the background read the same as the subject. In **Image** 31, the background light was set to overexpose by two stops. In **Image** 32, the background light was set to underexpose by one stop.*

exposed and will photograph two stops lighter than it really is (Image 31).

You can create a darker background by reducing the intensity of the background light. For example, if your exposure reading at the subject position is f8, adjust the intensity of the background light to f5.6. Expose for the subject at f8, and your background will be one stop underexposed and will appear darker than it really is (Image 32)

It is just as important to light a white background properly because, without the correct amount of light, a white background will photograph as a dirty gray rather than as a clean white. In theory, you should flood a white background with enough light to give you the same aperture reading on your incident light meter that you got when you read for exposure. If you like clean white backgrounds, you may want to add 1/2 to 1 stop more light on the background, depending on the film you use.

■ Lighting a High Key Foreground

Lighting a white background is easy. Lighting the foreground of a full length portrait is harder. It is very difficult to illuminate a foreground area separately, but if you use the right kind of light, you can make your keylight do double duty. Here's how. As your keylight, use a large light source designed to spread light in several directions. A Larson Starfish, a Photoflex Whitedome, a Westcott EPS Halo, or a large soft white umbrella are all good choices because they are soft and spread light over a wider area. Set your light for

the effect you want and then aim it down toward the foreground (diagram 18). If you adjust the height and tilt of the light properly, your subject will be illuminated by light coming from the upper part of the light modifier, and the foreground will be illuminated by the slightly more intense light coming from its center and the lower part of the light source. The design of the Photoflex Whitedome allows light to pass through its bottom panel toward the foreground area, so it may not require as much tilt. Meter readings and Polaroid tests will help you master the technique of lighting white foregrounds.

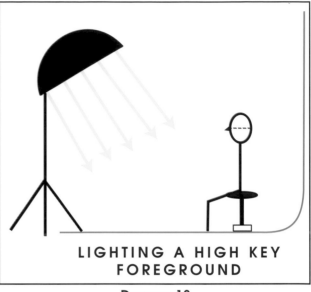

LIGHTING A HIGH KEY FOREGROUND

DIAGRAM 18

■ Accent Lights

• **Hair Lights.** Accent lights are seldom necessary, but they can turn an ordinary portrait into one that is outstanding. The most commonly used accent light is a hair light. Unless you use a hairlight, your subject's hair will probably photograph somewhat darker than it really is and may even blend into the background. A hairlight, which is sometimes called a separation light, separates the subject from a dark background, and allows you to control the tonality of the hair.

Your hairlight should be placed high, slightly behind the subject and aimed toward the subject's hair. You can use any type of light source as long as you can adjust it so that it reaches only those areas you want to illuminate. One exam-

Image 33 was shot without a hairlight. Image 34 was shot with a hairlight set to the exposure reading. Image 35 was shot with a hairlight set one stop above the exposure reading.

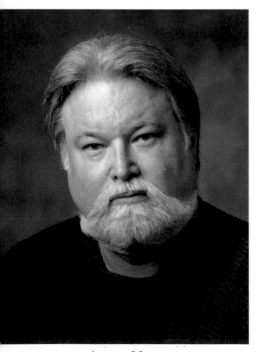

IMAGE 33

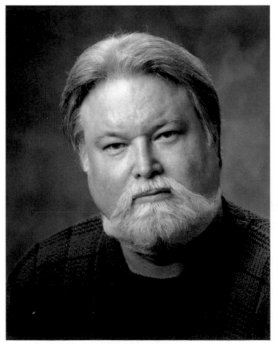

IMAGE 34

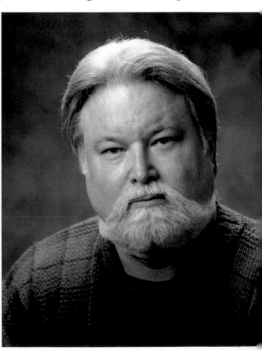

IMAGE 35

ple is a strobe with a small reflector, fitted with a grid spot. If you use soft light sources, such as umbrellas or soft boxes, to illuminate your subject, you will like the soft quality of a strip light, which is a long, narrow soft box. A strip light, fitted with louvers, allows you to restrict light to specific areas easier than other soft light sources. Regardless of the type light you select, it is best to mount it on a boom and position it high and behind your subject.

When you use a hairlight, you should adjust its intensity until your incident light reading is equal to, or more intense than, the subject reading. If the reading is equal, or close to equal, you will get a natural effect. If you choose, you can increase the intensity of the hairlight to produce a more dramatic effect. Image 33 was made without a hairlight. Image 34 was made with the hairlight adjusted until its intensity was equal to the exposure reading. Image 35 was made with the intensity of the hairlight adjusted until it read one stop more than the exposure reading.

• **Kicker Lights.** Hairlights aren't the only type of accent lights. Kicker lights are accent lights that can be added from any position and allow you to illuminate only the area you want to accent. For example, a kicker can be behind and to the side of the subject as in Diagram 19. The kicker adds a rim of light along the side of the subject's face. This rim of light adds interest and sparkle to the photograph. Image 36 was made without a kicker. Compare it with Image 37. The lighting effect is almost identical except

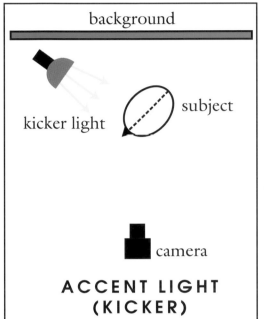

background

kicker light subject

camera

ACCENT LIGHT (KICKER)

DIAGRAM 19

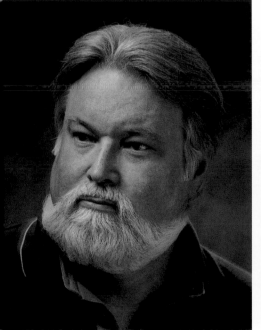

IMAGE 36

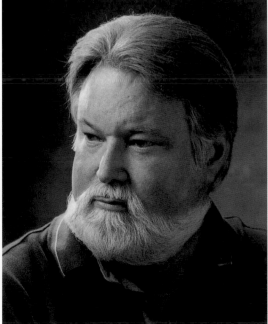

IMAGE 37

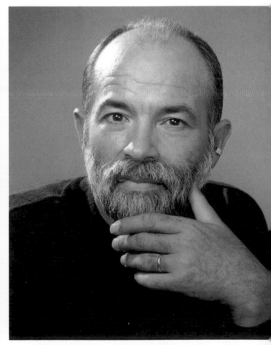

IMAGE 38

for the highlight that runs along the side of the subject's face and down to his shoulder.

If you want a more dramatic effect, you can increase the intensity of the kicker and you can also move it around until it illuminates more of your subject (Image 38).

■ Area Lighting

Area lighting is a concept that involves lighting the picture area to provide generally pleasing effects, rather than lighting the subject in detail. Area lighting is a natural, and in some cases a must, when photographing children. It can be just as effective when working with adults. However, you must be willing to give up some of the fine tuning that photographers like to do.

There are different ways to light an area. The one essen tial is that it must cover enough space to allow your subject room to move around. The two diagrams that follow show different types of area lighting. Diagram 20 shows the setup used when photographing most of the children that appear in this book, including Image 39.

"Area lighting is a natural, and in some cases a must..."

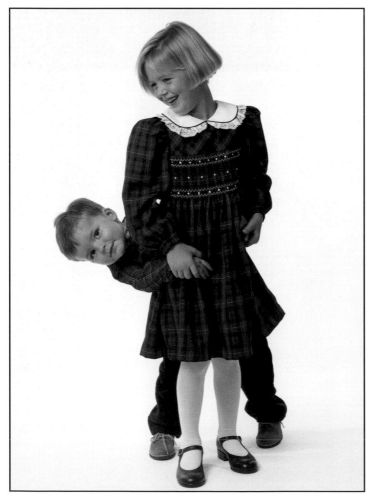

IMAGE 39

AREA LIGHTING

DIAGRAM 20

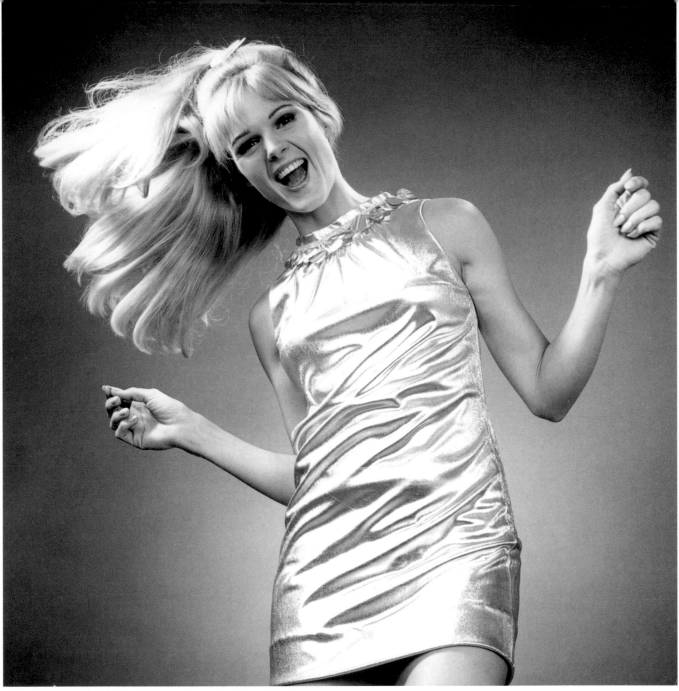

IMAGE 40

Area lighting can also be used for more dramatic photographs. Diagram 21 shows the set-up. Strong accent lights were added to the basic set-up for Image 40 creating a feeling of motion and excitement. When you use area lighting, you should use broad light sources as both the main and fill. A big umbrella or soft box is recommended. You can use smaller light sources on the background. You can also use small light sources as accent lights as shown in Image 40.

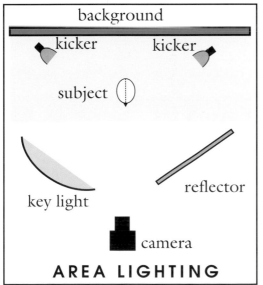

AREA LIGHTING

DIAGRAM 21

③

Basic Photographic Techniques

■ Introduction

Before we move on to a less technical area of photography, we need to get to the most basic of the basics – calculating a correct exposure and controlling lighting ratios. The first is probably the most basic of all photographic skills, as well as being the most essential. However, we don't want to get so caught up in technique that it gets between us and the people we photograph. Portrait photographers work with more forgiving color negative films rather than more demanding, "what you shoot is what you get" transparency materials, so don't be a nit-picker. Your goal should be to stay well within the generous exposure latitude of modern color negative materials, not to be obsessive about absolutely correct exposures.

Exposure is pure technique. Ratio control is part technique and part art. There was a time when we were told to work toward a 3:1 ratio for studio portraiture. Don't get caught up in a formula that is so rigid. An image created at a 3:1 ratio, using some modern films, may be flat and uninteresting. Try different ratios. Turn to page 52 to learn a simple way to think about lighting ratios.

■ Calculating the Correct Exposure

Learning to calculate an accurate exposure isn't hard, but like many things in photography, it is best learned by personal testing rather than by following a formula. It is generally accepted that a flash meter should be used in its incident mode for portrait photography. Photographers aren't nearly as ready to agree on how the meter should be used. According to information published in almost every meter's instruction manual, an incident light meter should

> "Don't get caught up in a formula that is so rigid."

be equipped with a hemisphere-shaped light receptor, held at the subject position and aimed toward the camera. There are those that don't agree. Some say you should aim the hemisphere at the keylight instead. Others say you will get more accurate exposures if you replace the hemisphere with the flat disk that is usually used to read lighting ratios. Who is right? Your tests, rather than an instruction manual offering some expert's opinion, will provide the answer. Here is how to run the test.

1. Load your camera with a transparency film such as Kodak's Ektachrome 100 SW rather than the negative film you use for portraiture. Why? When you shoot transparency film there is no lab technician to correct your errors or to add errors of his own. What you shoot is what you get, and what you get when you shoot is what you need to determine which metering method will work best for you.

2. Set up your lights and adjust the intensity of your keylight and your fill light until the difference between the two readings is 1 to 1-1/2 stops. Light your background enough to assure adequate separation between the background and the subject. Do not use a hairlight or any other accent lights. If light from an accent light falls on the meter's receptor, it may interfere with an accurate exposure reading.

3. Start out with the hemisphere-shaped receptor. Hold the meter at the subject position and aim it toward the camera. Take a reading and make three exposures bracketed at one stop intervals. You will need bracketed exposures, because you must evaluate a well exposed transparency made by each method.

4. Switch to your meter's flat disk receptor. Take a new reading and repeat the three exposure test series.

5. Switch back to the hemisphere-shaped receptor and take another exposure reading. This time aim the meter toward the keylight. Take your reading and repeat the test series.

6. Switch to the flat disk and repeat the series. Aim the meter at the keylight again and repeat the test series based on this reading. When you finish, you will have four sets of bracketed exposures, each based on an exposure reading made using a different method.

The following three photographs were made on Ektachrome E 100 SW, which is a color reversal film producing transparencies with a little extra warmth. The readings were by the book, with the dome shaped receptor of the exposure meter aimed at the camera. Image 41 was made using an aperture set one stop less than the meter

"Your tests... will provide the answer."

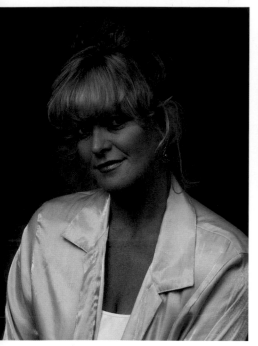

IMAGE 41

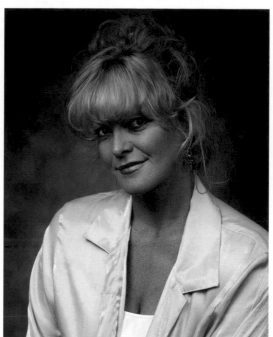

IMAGE 42

IMAGE 43

reading. Image 42 was made with the lens set according to the meter reading. Image 43 was made using an aperture one stop more than the exposure reading.

■ F-Number System of Ratio Control

This exercise is designed to help you master the F-Number System of Ratio Calculation. Master it and you will be able to predict the difference in tonal value between the lighted side and the shadow side of your subject's face. Keep careful records. If you have a Polaroid back for your camera, make a Polaroid test, followed by test negatives on whatever film you plan to use. Black and white Polaroids are satisfactory, even though you are testing color film.

The first step in doing this exercise is to copy the test record form that is in the back of the book and fill in the column headings. Set up a column for each light you plan to use (keylight, fill light and background light, if needed). Don't use a hairlight or other accent light at this point. An accent light that falls on the meter's receptor can cause a false reading. Most importantly, set up a column to record the number of f-stops difference between the keylight and the fill light. Then follow this procedure:

1. Pose your subject. Place your fill light in one of the positions described in the fill light section of Chapter 2.

Test Series

Images 41-43 were part of a test series I ran recently. The test included readings made with the dome aimed at the keylight, and readings made using the flat disk receptor, as well as exposures made according to the manufacturer's instructions. There were minor differences in exposure, but based on the results of my test, either of the methods tested are certainly accurate enough – particularly when you consider the wide latitude of the current crop of color negative films. Run the test for yourself. You'll probably conclude that, for studio portraiture, the controversy about the best metering method is really much ado about very little.

> *"... aim the meter at the keylight and take another reading."*

Turn on your fill light only. If you have a flat disk receptor for your meter, use it for this test. Aim the disk at the fill light and take your first reading. Record your reading in the fill light column of your test record.

2. Turn on your keylight and position it as desired. With both lights on, aim the meter at the keylight and take another reading. Adjust the intensity of the light until it reads one stop more than your fill light. Record your reading in the keylight column of your test record. The difference in f-numbers is 1. Enter 1 in the difference in f-stops column. Calculate your exposure and make your first test photograph (Image 44).

3. Adjust the intensity of your keylight until it reads two stops more than the fill light. Enter the new reading in the keylight column and enter the difference, which is two, in the difference in f-stops column. Calculate your exposure and make your second test photograph (Image 45).

4. Adjust the intensity of your keylight until it reads four stops more than the fill light. Enter the new reading in the keylight column and enter the difference, which is three, in the difference in f-stops column. Calculate your exposure and make your third test photograph (Image 46).

The illustrations provided (Images 44, 45 and 46) are for demonstration purposes only. To predict the effect you will achieve at any given ratio, you must run your own tests. A difference in film and/or processing can make a very distinct difference in the results you will get. When you test, don't stop where this test stopped. Try adjusting the differ-

IMAGE 44

IMAGE 45

IMAGE 46

ence between the main and fill lights to a higher difference in f-stops to see how far you can go and still have satisfactory shadow detail. Then try adjusting the difference in the intensity of your lights until there is no difference between your keylight and fill light readings. The more you know, the better you can predict the results you will get at different ratios.

The only lights that you should read to determine lighting ratio are the keylight and the fill light. However, you should light your background enough to provide good separation between it and your subject. For this test, a highly diffused Balcar Minibloc, adjusted to read one stop less than the keylight, was directed toward a light gray background.

This method of reading lighting ratios works only when you are using a light as your fill source. You must modify the method if you use a reflector fill. Use your meter's flat disk receptor if you have one. First, read your keylight and record that reading. (If your meter has a memory function, use it.)

There are two ways to read the light that bounces from a reflector. First, hold your meter beside your subject's face on the shadow side and aim it at the camera. Second, aim your meter at the reflector. Try both methods. You'll probably find that the readings are different. That isn't important. You aren't trying to establish a true ratio, just a working reference. Just be consistent. Although you won't be able to say that you used a specific ratio, you will be able to maintain reasonably consistent ratios if your metering technique is consistent.

Author's Note

When we talk technique, it's important for us to be talking about the same thing. When I was studying lighting ratios, I read two books. Both had charts showing the number of stops difference required to produce a wide range of different ratios. The two charts didn't agree, so instead of juggling numbers, I decided to work with the raw data that my meter gives me.

IMAGE 47

IMAGE 48

The meter was aimed at the reflector when these two photographs were made. There were three stops difference between the keylight reading and the reflector reading when Image 47 was made, and 3-1/2 stops difference between the keylight and the reflector when Image 48 was made. If you calculate a conventional lighting ratio, based on the meter readings, your answer will be higher than you would expect based on test results. This isn't important. What is important is to find an easy to use method that will help you predict the difference in tone between highlights and shadows.

■ True Tonality

The terms "tonal value," "depth of tone," and "true tonality" may seem very technical, but they aren't. "Tonal value" and "depth of tone" are terms used to describe how light or how dark an object appears in a photograph. "True tonality" refers to the tone of an object as it appears in the photograph. That object is said to have true tonality if the depth of tone matches the depth of tone of the object itself. Depth of tone can be stated scientifically by referring to the reflectance of the image. For example, the standard photographic gray card represents the middle shade of gray in a gray scale and its reflectance is 18% (Diagram 22).

The tone of an object in a photograph depends on two factors, the tone of the object and the amount of light that falls on that object. If you photograph an evenly lighted box that is the same color on all sides, each visible side will appear at its true tonality. On the other hand, if you set up your lighting so that the top of the box receives one stop more light than the two sides, and if you base your exposure on a reading made of the top of the box, only the top will

> "Depth of tone can be stated scientifically..."

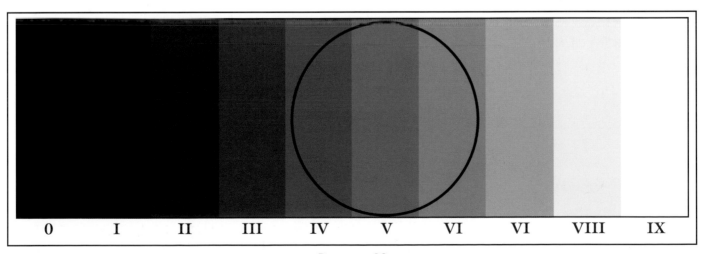

| 0 | I | II | III | IV | V | VI | VI | VIII | IX |

DIAGRAM 22

be recorded at its true tonality. The two sides will be recorded as darker shades of gray.

The same principle applies to a face in a portrait. If you pose your subject at a 45° angle and set up your keylight to illuminate both sides of the face equally, both sides will be recorded at their true tonality. If you change your lighting so that one side of the face receives less light than the other, it will be recorded as a darker tone.

In theory, this seems to indicate that you should always use the reading indicated by your incident light meter, regardless of the depth of tone of your subject. Like most theories there are times when it doesn't work. For example, if you are photographing a person with very dark skin, you may want to open your lens 1/2 to 1 stop, depending on how dark your subject's skin is.

"The same principle applies to a face in a portrait."

"Subject Failure"

I am sure there is a more scientific explanation for this failure of a simple technical principle. However, we usually assign problems such as this to the catch all "subject failure." If there is a failure, it is the failure of human skin to react exactly the same way as a zone on a gray scale. Many of my customers are African-Americans. There is a great difference in the tonal range of African-Americans' skin. I have learned to make a reasonably accurate estimate of the amount of exposure increase required based on the individual I am photographing. When I am in doubt, I make Polaroid tests. Although there isn't as much difference in the depth of skin tone among Caucasians, you will find that the same problem exists.

④
Posing for Studio Portrait Photography

◼ Introduction

Posing is part of the broader art of composition. Although there are rules with awesome sounding names such as "The Law of the Golden Mean," and although some photographers have created a mystique about using these "laws," good posing is really a simple idea. Whatever those who concern themselves with such things may say, the only important thing is that your subject be presented in a pleasing way.

Although we will cover rules of composition in this chapter, your goal should be to learn to pose your subject without thinking a lot about posing. One way to learn is to be a people-watcher. You may be surprised to discover how many good ideas you can get just by keeping your eyes open.

In spite of my feelings about posing, I have included a lot of details in this guide that may seem like inflexible rules. Don't think that any of it is the last word on portrait posing. Instead, I hope you will take my suggestions as sort of a starting point – some things for you to look at and consider.

> "... learn to pose your subject without thinking a lot about posing."

◼ Composition

• **Composition and Format.** The most basic task in composition is selecting a format for your photograph. Should your portrait be vertical, horizontal or square? When should you decide? The proponents of so called "ideal format" cameras, say it should be done in advance. Square shooters like to leave the final decision until they have negatives or proof prints in front of them. Actually, neither way is best. Ideally, the subject of your portrait,

IMAGE 49

IMAGE 50

rather than the shape of your negative, should determine the shape of the photograph. In actual practice, you will keep on selling portraits that are the same 4:5 or 5:7 ratios that you've always sold. The public is conditioned to think that way and we are conditioned to sell that way. In fact, we are so conditioned to think in standard formats that even square format shooters often neglect the square composition.

Although you will sell standard sizes most of the time, experiment with other formats. Try squares, and rectangles that depart from the norm. Try matting and custom framing these unconventionally shaped prints, using minimal frames designed to compliment your art rather than the art of the frame-maker. You may sell the same old sizes, but your clientele will know that you are thinking.

If you are a square shooter, you'll see the value in printing square right away. Sometimes you need a feeling of space around your subject. Image 50 was cropped to the usual 5:7 ratio. Image 49 was printed full frame. See the effect of extra "living space"?

Go on to other shapes. Most photographs have a natural direction. The natural direction of Image 51 is a strong vertical, with most of the empty background area

Image 50 was cropped to the usual 5:7 ratio. Image 49 was printed full frame. See the effect of extra "living space"?

" ... we are conditioned to sell that way."

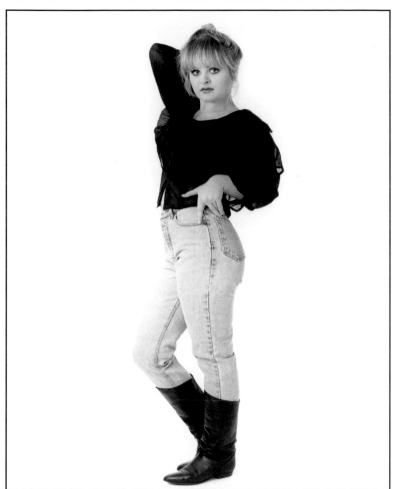

IMAGE 51

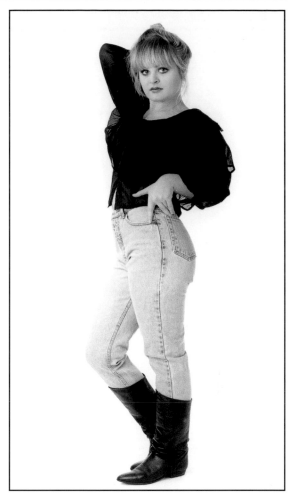

IMAGE 52

*With all the empty background area on the sides, **Image 51** can be cropped to a strong vertical, as seen in **Image 52**.*

"... it is a valid guideline – but certainly not anything as strong as a law."

on the sides. It is a natural for "Slim Jim" cropping as shown in Image 52. Neither treatment is the right way, and neither is wrong. The value in cropping in an unusual way is that it offers you a different way to present your work.

• **The Rules.** The most familiar rule in photography is the law of thirds. According to the law of thirds, you should divide your focusing screen into thirds, in both its vertical and horizontal planes. When you pose your subject, you should then place the center of interest at one of the points where vertical and horizontal lines intersect (Diagram 23). The law of thirds works, but probably better if it is applied instinctively rather than by conscious effort.

There is another law that states that the center of interest of a photograph should be the lightest part of the photograph. Like the law of the thirds, it is a valid guideline – but certainly not anything as strong as a law. For example what about portraits with white backgrounds? Obviously the background is lighter than the subject, and it certainly

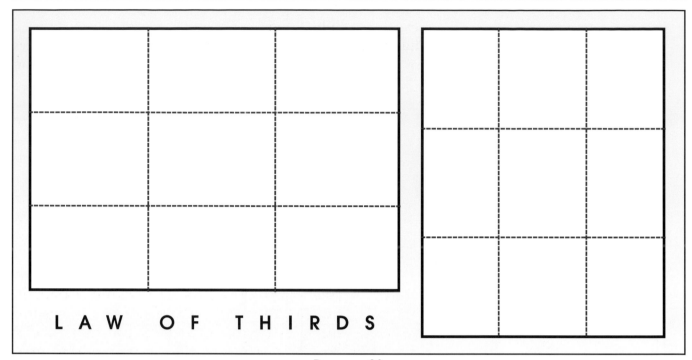

L A W O F T H I R D S

DIAGRAM 23

isn't the center of interest. An exception that proves the rule? Exceptions don't prove rules.

A convention speaker once said that "Any photograph that follows the law of golden symmetry is a good photograph and any that doesn't is bad." A listener questioned him, "What if the photograph has some quality that makes it so compelling that you come back to it time after time?" The speaker said that doesn't matter, it is still a bad photograph. That seems completely wrong. Philippe Halsman, the great photographer, seems to agree. In a letter to the author he wrote, "In the name of progress we must liberate portraiture from the rigidity of accepted portrait formula."

• **The Positive Use of Negative Space.** Look back at Image 49. It shows the effect of increasing the amount of space around the subject by making a square print from a square negative, rather than cropping to a conventional proportion. The same principle of using empty space (called negative space) as part of your composition, applies regardless of the format. You can think of space around the subject of a portrait as "living space," space that creates the illusion that the subject could move, that he or she isn't crowded. If you work with a square format, you can simply print square. If you want to add negative space when composing conventionally, you will need to move your camera further from the subject.

• **Learning Composition By Looking.** One way to learn composition is by looking. First, work with a selection

"... think of space around the subject of a portrait as 'living space'..."

of photographs you've already made. Choose a series of full frame proofs or prints. Using a pair of L-shaped pieces of cardboard, see how many different possibilities you can find in each photograph. Start with conventional proportions such as 4:5 or 5:7 and then go on to less conventional cropping. You will learn more than you might expect by isolating interesting areas and studying the relationship between different compositional elements.

Carry this idea of learning by looking out into the real world. Pick out things that interest you. Look at them and try to arrange them into a photographic composition.

Try this exercise. Cut an opening the size of your negative in a piece of cardboard. Hold it in front of your eyes at a distance that is equal to the focal length of the lens you plan to use. You'll see an approximation of the composition. If you want to see a proportion different from the proportion of your negative, mask the opening in your card to show the proportion you want to see. For example, if you use a camera that makes a square negative, and you want to see how it crops at a 4:5 ratio, you'll need to make the opening in the card 1-3/4" x 2-1/4".

■ Posing the Head and Shoulders

The best way to pose someone for a head and shoulders portrait is to start at the point of support and build a solid base for the upper body and the head. Here's how to do it.

Use an adjustable posing stool if one is available. If you don't have one, you can adapt a regular stool or a chair by using books or blocks to make adjustments in height. When the posing stool is properly adjusted, your subject's upper legs should be parallel to the floor or should slope down slightly. Her feet should reach the floor, her legs should be extended to a comfortable distance in front of her. Her back should be straight (Image 53). If your subject is seated too low, it will be hard for her to avoid slumping. If she is seated too high, she will feel uncomfortable and insecure.

The second step is to decide which side of your subject's face you want to feature. Ask her to face straight into the camera. Look at her very

About the "Rules"

I hope you can use this information as you study composition. I also hope that you won't get caught up in a lot of rules. Creating a composition should be easy and natural, never forced. As far as composition goes, my wish for you is that you will develop a sense of perceptive sight so acute that you never need to think of the Law of Thirds again.

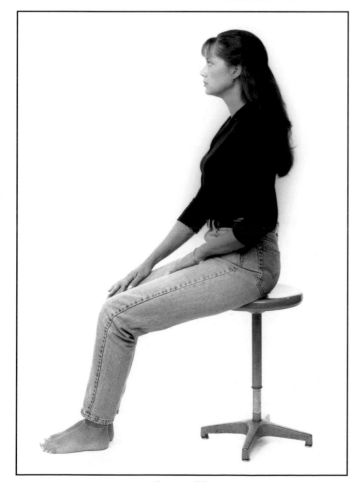

IMAGE 53

carefully under flat lighting. Few, if any, faces are symmetrical in shape (Image 54).

Years ago, a popular magazine demonstrated this in a dramatic way. One of the magazine's photographers made full face portraits of a number of people, using very flat lighting. He made three prints of each negative and then he turned the negative upside down to reverse the face and made two more prints. One print was published as it was made. The other prints were cut down the center and reassembled to make faces composed of two right halves and two left halves. This experiment proved that every face is made up of two sides that are quite different from each other. The slimmest side of most faces is the photogenic side. You should pose your subject to reveal the shape of this side of the face more than the other. This means that you should pose your subject with the fullest side of her face toward the camera, so the slimmer side will be outlined against the background.

While this is a good rule of thumb, there are factors concerning specific features that override the general rule. The first is your subject's nose. Does it curve toward one side or the other? If it does, shoot into the curve. This will straighten the nose, at least partially. Another factor is hair. If her hair looks better from one side than the other, photograph the side that looks best. What about a lazy eye, scars, birthmarks or other blemishes? Each of these factors is more important than the principle of the photogenic side.

There are three basic views of the face in portrait photography. They are the profile, full face and 3/4 views. The term "3/4," when used to describe a pose, isn't an exact description. Instead, it is used to describe any view of the face between a full face and a profile.

Once you have decided which side of your subject's face is the photogenic side, you can choose between two basic positions for a 3/4 view of the face. The first shows the

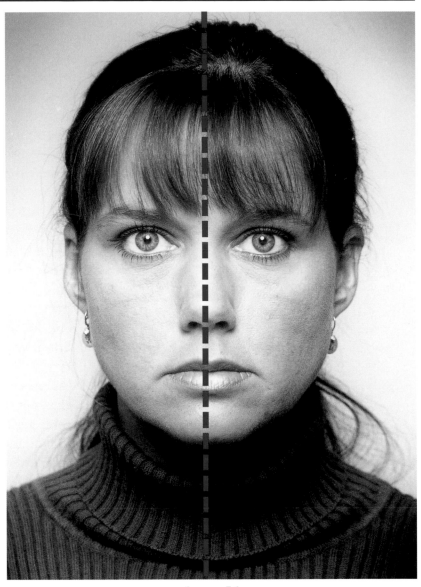

IMAGE 54

Few (if any) faces are perfectly symmetrical in shape.

"There are three basic views of the face..."

IMAGE 55

IMAGE 56

head and body turned toward the same side of the lens axis, but at a different angle. The second position is the "contra" body position in which the head and body are turned in different directions.

Start by posing your subject with her body and head facing the same direction. Ask her to turn to an angle of about 45° to the camera. One way to direct this pose is to move to the point you want the body to face and ask your subject to turn until she is facing you. Once her body is in position, pose her hands and arms. Although her hands won't show, their position is important. Ask her to place her hands in her lap and to extend the hand on the side furthest from the camera toward her knee. If her arms are too close to her body, the base of the portrait will be too narrow and your portrait will look top heavy. When you extend the far arm, you build a wider base. This will be a good support for her head and upper body.

As a general rule, you don't want your subject's head and body to be at exactly the same angle to the camera. Position it by moving back toward the camera until you reach the point where you want her to face and ask her to turn her head toward you. Go back to the camera and check the pose on the focusing screen. Repeat this until her face is at the angle you want (Image 55).

The contra body pose shows an alternate head and body relationship (Image 56). Once you have decided which side of your subject's face is the photogenic side, you can choose the head and body relationship shown here or the relationship shown in the preceding photograph. The contra body pose is used to create a sense of motion and a feeling that the subject is an active and dynamic person. At least, that is what the rule book says, but don't always be a rule book photographer. The whole reason for going through the exercises in this book is to develop a sense of what works and what doesn't. Try almost anything, and as your confidence grows, let your eye and your experience tell you what works. Remember, anything that looks good is good and anything that doesn't is bad.

At this point you may want to adjust the tilt of your subject's head (Image 57). This is the traditional "feminine" tilt. The basic composition is built around a curved line that starts at the top of her

head. It's "rule book" correct, but don't think you have to follow the rule every time. In Image 58, the tilt of the head is toward the camera. Although it doesn't conform to the traditional rule book, it is just as good as the preceding photograph. The difference is in the mood it projects.

Once the pose is set up, where should the subject look? Images 59 and 60 are almost identical except for the position of the subject's eyes. In Image 59 the subject is looking slightly to the right of her nose axis. The feel here is less personal than the feel in the second photograph (Image 60). Asking your subject to look into the lens of the camera opens up the possibility that you will capture a portrait with a feeling of intimacy that cannot be achieved any other way.

• **The Full Face Portrait.** The angle of the face that you choose to photograph depends on the subject and the statement you are trying to make. A full face portrait can have an intensity that you won't achieve in other views of the face. Some of the most powerful portraits that have ever been made are full face portraits. An excellent example is the famous Philippe Halsman portrait of Albert Einstein. Most of you have seen it. It has been reproduced on everything from postage stamps to posters. When you crop as close as Halsman did in creating this portrait, you can forget about getting help from a picturesque setting, you can forget about attractive clothing, you can forget about interesting props. All you have going for you is an interesting face, your skill with light, and even more important, your ability to draw something special out of your subject.

Usually you will want to position your subject's body at an angle, but there are times that a completely straight-on view works best. For example, posing your subject's body straight toward the camera creates a feeling of stability.

When making a full face portrait, consider the height of the camera (image 61). Did you ever stop and think that your subject seldom sees himself from any level except the eye level view he sees in his mirror? He may look very different from a higher or lower angle. For example, if you shoot from a lower angle, you may show your subject things he doesn't even like to think about, things like an extra chin or a sagging throat. Maybe, from your lower point of

IMAGE 57

IMAGE 58

IMAGE 59

IMAGE 60

IMAGE 61

*In **Image 59** the subject is looking slightly to the right of her nose axis. The feel here is less personal than the feel in **Image 60**.*

*When making a full face portrait, consider the height of the camera, as in **Image 61**.*

view, he does look like "that" (whatever "that" is). If you show him "that," though, you will earn the title of the worst photographer in town. This doesn't mean that you should always shoot at eye level, but you should use eye level as a starting point for any head and shoulders portrait.

• **Posing The Profile.** Ask your subject to sit at an angle of about 45° to the camera. Move to the point where you want her to look and ask her to turn her head toward you. Go back to the camera and check the focusing screen. Do you see a clean profile with none of the cheek furthest from the camera showing? If it shows, ask her to turn a little more away from you. Recheck the focusing screen and keep changing her position until you see the view that you want. Watch her eye. If you don't see enough of the iris, ask her to look at a point a little more toward the camera. At this point, the pose is complete (Image 62).

To create the alternate profile view seen in Image 63, ask your subject to sit with her back toward the camera and to

"Go back to the camera and check the focusing screen."

Image 62 shows a simple profile pose.
Image 63 shows an alternate profile pose.

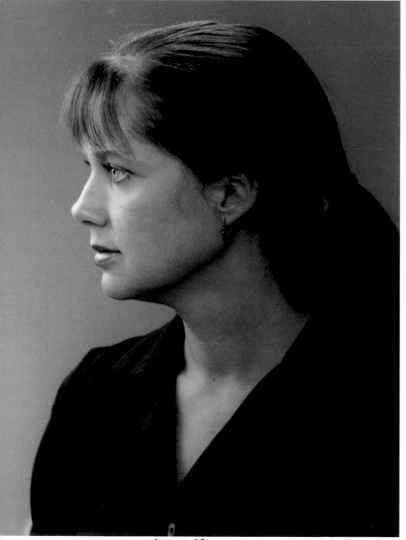

IMAGE 62

IMAGE 63

turn to an angle of about 45° to the camera. Move to the point where you want her to look and ask her to turn her head toward you. Move back to the camera and check the focusing screen. You may see lines in her throat that are too pronounced. If you do, ask her to tilt her head away from the camera. Sometimes this will smooth those lines out and sometimes you will have to leave corrections in the hands of the retoucher.

■ Posing the Body

Building a base for a full-length portrait is a little more involved than building a base for a head and shoulders photograph. This is because, in full-length portraits, the legs and feet become part of the composition, as well as part of the body's support system.

> "... the legs and feet become part of the composition..."

• **Posing Circle.** You may find it helpful to imagine that your subject is standing within a circle and that the center of the circle is the weight-bearing point, which we will call the base point. In the beginning you may find that it will help if you use a real circle, drawn on a piece of poster board or scrap of background paper. Once you've drawn the circle, draw evenly spaced lines from the base point to the circumference of the circle. Use from twelve to twenty four lines and number each one (Diagram 24). There is a larger copy of this circle in the back of this book. If you choose, you may copy it and have it enlarged so that you can use it during practice sessions.

Pose the legs first, using an enlarged version of the circle shown or an imaginary circle. Try following these steps:

1. Ask your subject to turn to an angle of approximately 45° to the camera and place the heel of the foot furthest from the camera on the base point of the circle.

2. Ask her to shift the majority of her weight to the leg furthest from the camera.

3. Next, ask her to place the toe of her other foot on the circumference of the circle at the numbered point you chose. In Image 64, this toe is directed between #2 and #3, which keeps the feet close fairly close together. Refine the pose by asking her to flex her ankle

lens axis

DIAGRAM 24

so that her foot rests more toward its inside edge, and bend her knee in toward the other knee (Image 64).

4. The next step is to pose her torso and arms. First, ask her to twist just a little back toward the camera. You can choose from a variety of arm positions. In this photograph her arms are placed in a way that doesn't hide the lines of her body (Image 65).

5. Pose her head at the angle you desire and the portrait is complete(Image 66).

IMAGE 64 IMAGE 65 IMAGE 66

IMAGE 67 IMAGE 68 IMAGE 69

• A Second Starting Point.

1. Start as before by asking the subject to place the heel of the foot furthest from the camera on the base point. This time ask her to position her toes along the line that leads to #4. Ask her to position the toe of her other foot at #23, let her knee swing in toward her other leg, and raise her heel off the floor (Image 67).

3. Pose her arms. You will use these poses more when photographing a woman wearing street clothes than in

IMAGE 70

something that reveals her body lines as much as a leotard. If you are working with a model wearing something as form-fitting as this, you can position her arms and hands to cover a bulge here and there. Notice that her hips and her shoulders are at a slightly different angle, with her hips turned a little more away from the camera than her shoulders. This is a slenderizing angle (Image 68).

4. Pose her head just as carefully as you would if you were doing a head and shoulders portrait (Image 69).

You can create variations on almost every pose that is based on the posing circle principle (Image 70). Although the model in this photograph has turned to the opposite angle, this pose is a variation on the last example. The most important difference is the change in the extension of her left leg.

• **Two Variations.** The next two poses are very much alike except for a change in the weight bearing foot.

1. Usually you will want to pose your subject with the majority of her weight on the foot furthest from the camera as shown in Image 71.

2. When making a full length or 3/4 portrait of a woman, you will usually want to pose her upper body at a slightly different angle than the angle of her hips, as shown in Image 72.

3. Once her body is in position, pose her head and face as you learned in the section on posing the head and shoulders (Image 73).

IMAGE 71

IMAGE 72

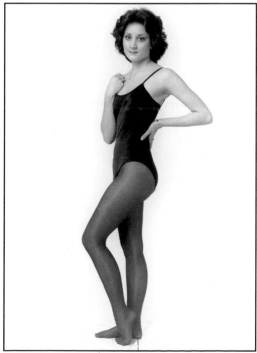

IMAGE 73

Rules were made to be broken, but with discretion. The next portrait breaks the rule we just talked about, the one that says the majority of the subject's weight should be on the foot furthest from the camera. There are times when you break this rule effectively.

Image 76 is very much like Image 71, except that the model has shifted her weight to the leg closest to the camera.

This whole series of photographs was made to show off the model's slender figure. Compare Image 75 to Image 72. With most of her weight on the leg closest to the camera, the curve of her hips is more pronounced.

Look at Image 76. Her body from the waist down was posed at one angle, her torso at a slightly different angle, and her head at a third angle. Use this principle to create the impression of a vital and active person in a still photograph. Notcie that the leg closest to the camera doesn't look as good as it does in Image 71. Imagine this portrait as a 3/4 length pose. That is the way to use this pose most effectively.

> "Rules were made to be broken, but with discretion."

IMAGE 74

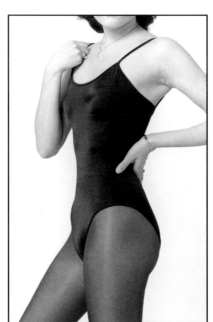

IMAGE 75

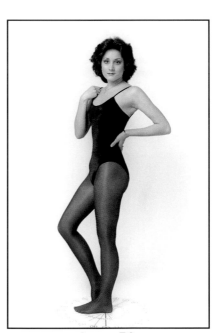

IMAGE 76

Although the model for the preceding photographs was dressed to show off her figure, this approach isn't intended for use only when photographing a woman in a form revealing outfit. Each of these poses can be just as effective when posing a woman wearing the kind of clothes she would normally wear for a portrait session. Try each of them, as well as others you'll create using the principle of the circle, and see how they work with a variety of fashions.

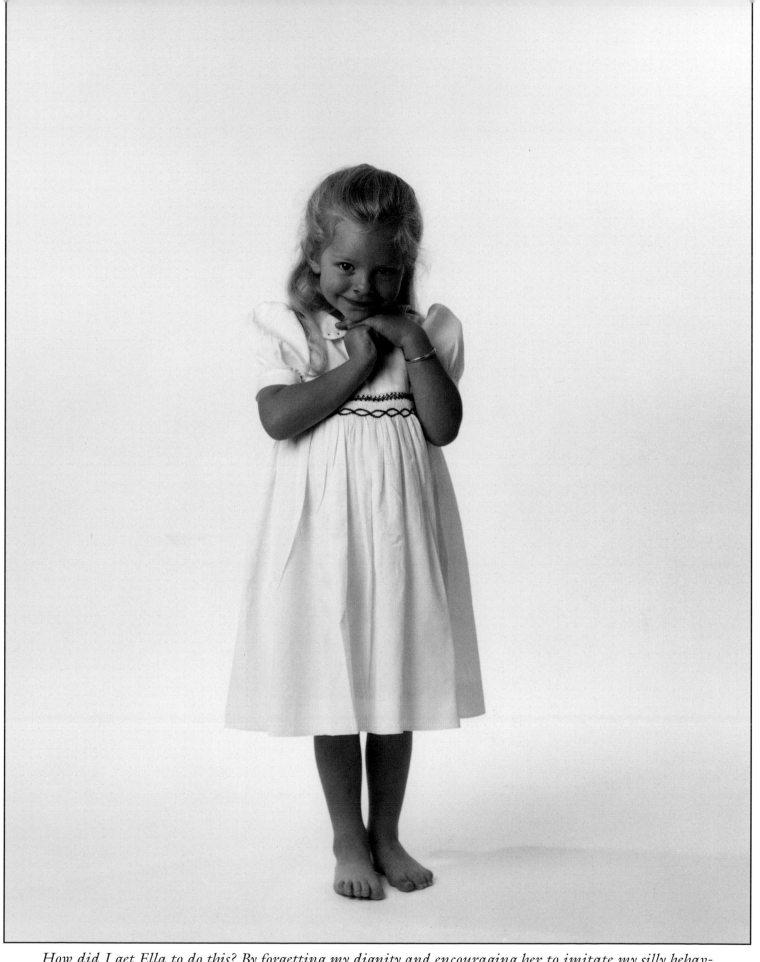

How did I get Ella to do this? By forgetting my dignity and encouraging her to imitate my silly behavior. I did this and she followed suit. This pose looks a lot better on Ella than it did on me.

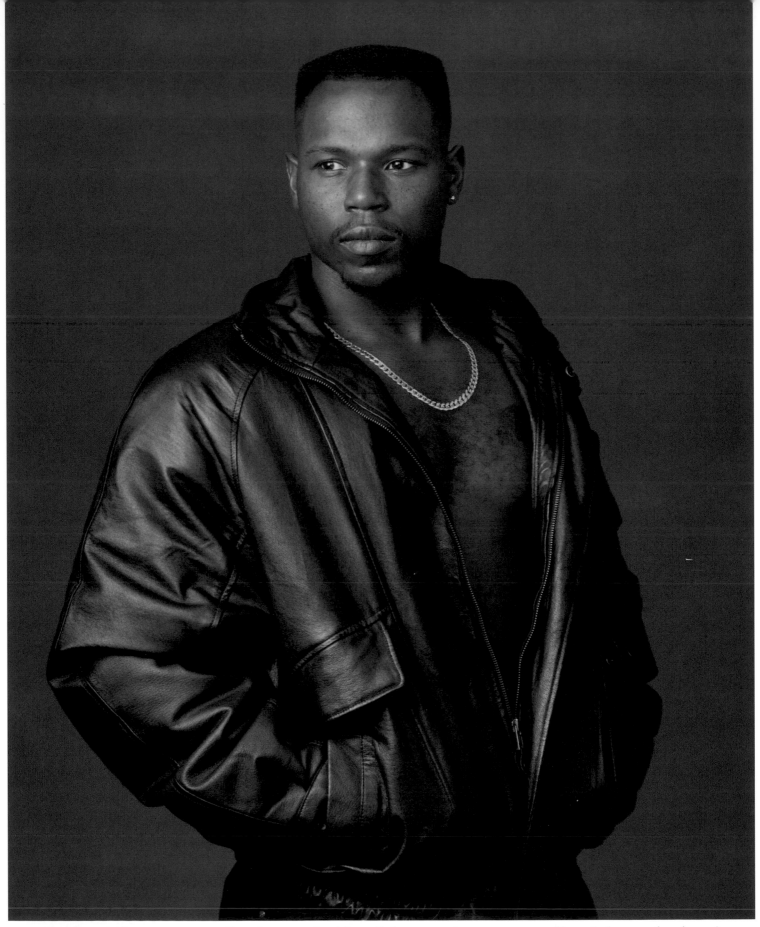

In theory, the exposure reading from an incident light meter is correct regardless of the tonal value of the subject's skin. In actual practice this isn't always so. When photographing an African-American or other person with very dark skin, you may want to open your lens by 1/2 to 1 stop.

The value of the posing circle isn't in establishing a set of rules of posing. Instead, it should be used as a reference during practice sessions. Use it to find out what works for you. Remember, the things that do matter are the principles of weight distribution and the relationship between different parts of the body.

Camera height is important in full length portraiture just as it is when creating a head and shoulders portrait. The lower you place your camera, the taller your subject will appear, while shooting from a high angle minimizes height.

■ Posing Portraits of Couples

The closeness between a man and a woman is emotional. There is no easy way to capture real emotion, so we use physical closeness to symbolize emotional closeness. The two series of photographs that follow show portraits of a couple built from two different starting points. The steps that lead up to the final portraits were made on a white background because both details and negative space show better on white. The final portraits are shown on a darker background which is in keeping with the lower key of the subject.

• **Facing the Same Direction.** Here is the set-up used to create one of the most basic poses.

1. Seat the couple as shown and adjust the height of the stools until the woman's eyes are at approximately the same height as the man's mouth (Image 77).

2. Ask the woman to extend the arm that is furthest from the camera to build the proper base for the composition, and to create a lead-in line.

3. Ask the man to put his arm around her waist to connect their bodies. Avoid letting his finger tips show at her waist (Image 78).

"... use physical closeness to symbolize emotional closeness."

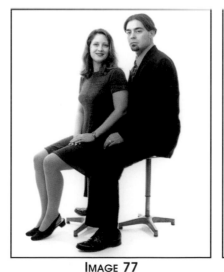

IMAGE 77

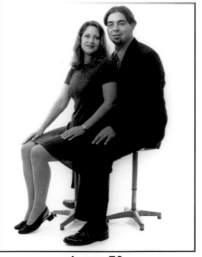

IMAGE 78

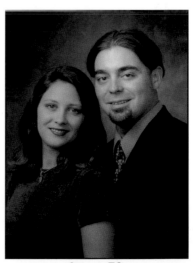

IMAGE 79

4. Ask them to lean their heads together and you are ready to shoot (Image 79).

• **Facing Each Other (Seated).** It is harder to pose a seated couple facing each other. The following steps show you one way to do it.

1. Raise the man's posing stool as high as it will go and lower the woman's as low as it will go.

2. Ask her to sit facing his stool and to extend her legs. (Image 80). Ask him to sit facing her and to put his foot on a block as shown.

3. Help her raise her stool as high as she can while keeping her legs under his. If his head is still too high in relationship to hers, you may have to adjust the height of his stool (Image 81).

4. Ask them to tilt their heads toward each other and you are ready to shoot (Image 82).

> "... you may have to adjust the height of his stool."

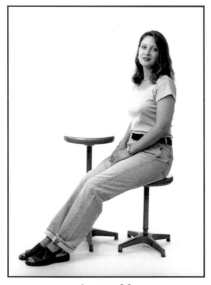

IMAGE 80

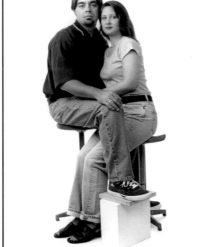

IMAGE 81

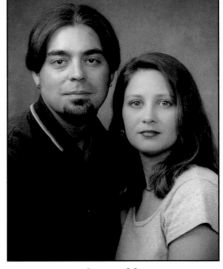

IMAGE 82

• **Facing Each Other (Standing).** There is an easier way to pose a couple facing each other – just ask them to stand. The only problem with this is ceiling height. You need a high ceiling to position your lights properly when posing standing subjects. Before space became so expensive, most photographers worked in studios with high ceilings. Today you may be lucky to find affordable space with ceilings higher than eight feet. The seated portrait bases shown above allow you to create pleasing portraits like the ones shown, even if your ceilings aren't high.

The poses for couples shown above are, of course, just two of an almost infinite number of possibilities. The four portraits on the opposite page show a few more examples of ways to pose couples.

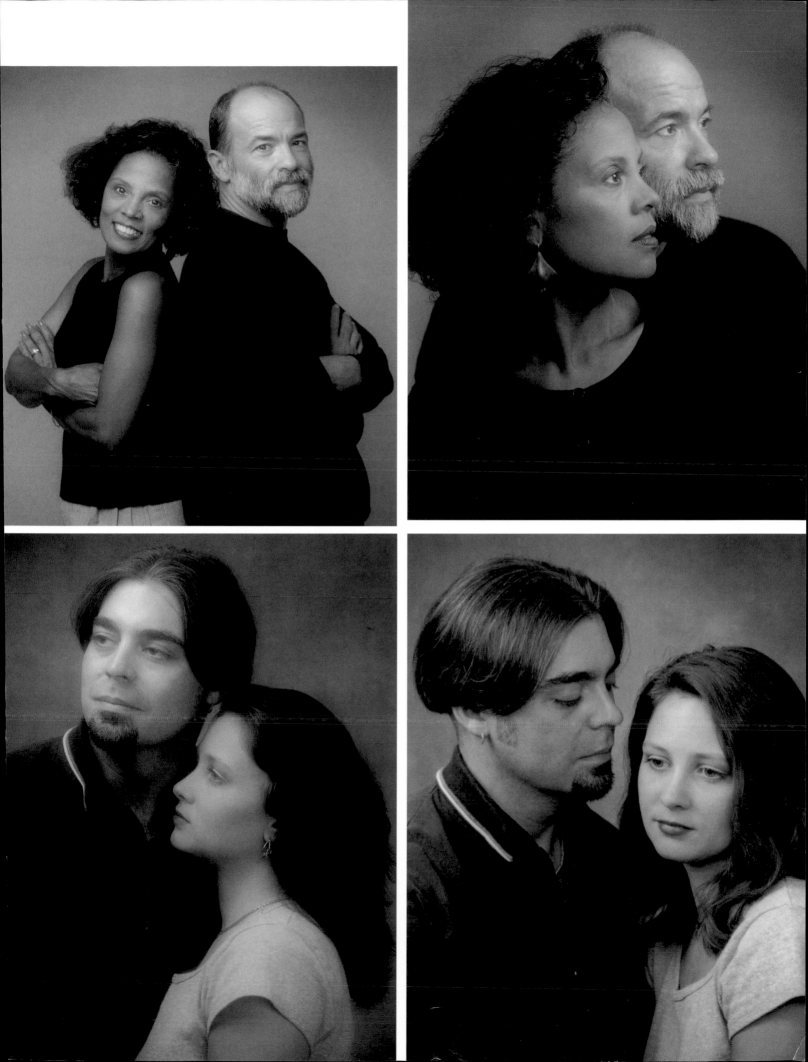

■ Informal Posing for Families and Small Groups

People today are more casual than they were in the days when Mom dressed everybody up in their Sunday best for every family portrait session. Casual is good. It's not just the kids who like to dress down for the occasion – quite often Mom is in jeans and barefooted, too. Going casual is good in another way. Mass market photographers, such as studios specializing in church directory and other promotional photography, don't usually have either the time or the space to create portraits like this. If you do, you will gain a competitive edge.

> "…. quite often Mom is in jeans and barefooted, too."

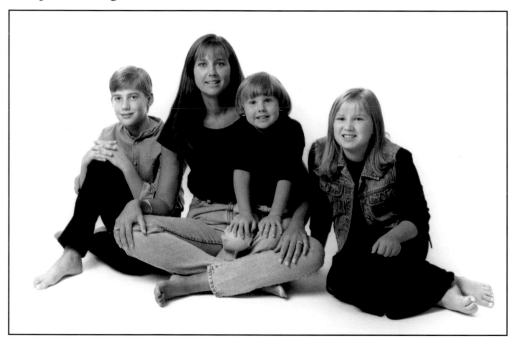

IMAGE 83

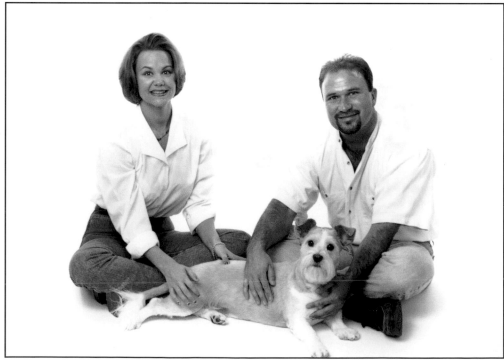

IMAGE 84

"Some of the best group arrangements almost build themselves..."

If you are photographing a mother and her children, such as the family shown in Image 83, pose mom first and place the kids around her. Let them try posing themselves and then refine their positions when necessary. Some of the best group arrangements almost build themselves – if you let them.

Remember, not every American family consists of a mom, a dad and three or four children. The people in Image 84 booked a family portrait session. Instead of the usual Mom, Dad and two kids, this family turned out to be a "Mom," "Dad" and a cross between a West Highland Terrier and a Scottie. All it took to get the terrier to perform were the words "Frosty Paws" (the name of a popular frozen treat for dogs). Mom and Dad were a little harder.

The people you photograph can be a good source of posing ideas (Image 85). At the beginning of this portrait session, one of the girls asked if they could pose themselves.

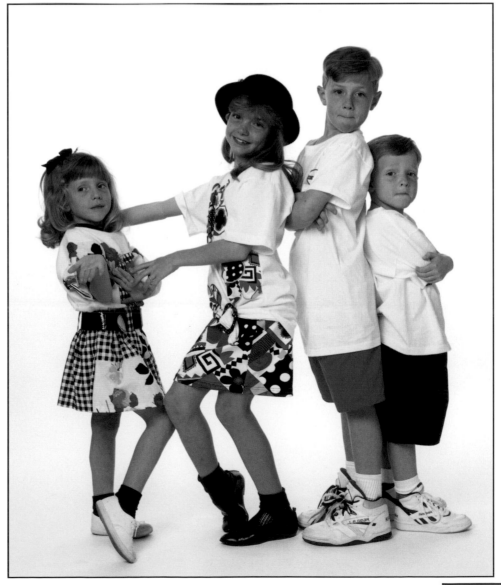

IMAGE 85

In a situation such as this, should you hang onto your "I am the expert attitude?" After all, what does a barely-teenage girl know about posing? Possibly quite a lot. The MTV generation comes complete with an imagination, and if you dig into that imagination, you may find a goldmine of posing ideas. Maybe a group of kids like this won't put the whole thing together for you, but watch them and you'll discover a wealth of ideas. Turn them into collaborators in the portrait process and together you will be able to produce portraits that have a humorous, almost Norman Rockwell quality.

Most of the kids in this group come from the photographer's "lost generation" – kids whose parents use their local photographer only for special occasion sittings and settle for school portraits for a record of their growth. Casual portraits of groups such as this, as well as portraits of individual children made in the same style, can bring that lost generation back to your studio and not just on a one shot basis.

The family you saw in Image 85 is an example. A few years later, equipped with a new set of posing ideas, they were back for an update. This style of spontaneous posing works for groups other than families. I have also used it for other groupings, including rhythm and blues singers and rock and roll bands.

"... watch them and you'll discover a wealth of ideas."

5

Special Photographic Techniques

■ Introduction

All you really need to create good portraiture is a camera with the right lens and a source of light, but there are other techniques that will enhance your portraiture and may even open up a whole new way of seeing. Each of the three techniques included in this chapter can do that.

Diffusion filters can be used as a corrective tool to reduce or eliminate the need for retouching, but that is only the beginning. A carefully selected diffusion filter can create a mood completely different from the mood of the same portrait made without a diffusion lens.

Vignetters allow us, to a degree, to create custom, "burned-in," low-key backgrounds, or to blend a subject dressed in white or pastels into a white background.

The tele-extender is a tool that was developed for a completely different purpose, but because it allows you to create tightly cropped, close-up portraits without distortion or excessive enlargement, it can add drama and impact to an ordinary head shot.

■ Diffusion Filters

There are four basic types of diffusers. They are:

1. BLACK TEXTURED DIFFUSERS. Examples are the Harrison & Harrison Black Dot Texture Screens (a set dedicated to the Hasselblad Pro lens shade) and the diffusers photographers make from black mesh fabric. They reduce contrast less than any other type of diffusion filters, but unlike other diffusers, they require an increase in exposure.

2. CONCENTRIC CIRCLE DIFFUSERS. This type of diffuser is available from a number of different manufacturers, including Lindahl, B+W and Harrison & Harrison. These

> "... there are other techniques that will enhance your portraiture..."

work best at wide to moderate apertures and diffuse very little at small apertures.

3. DIFFUSERS WITH AN OVERALL TEXTURE. At small apertures, these diffusers work better than concentric circle diffusers. However, they reduce contrast more than other types of diffusion filters. They are available from other manufacturers, but Harrison & Harrison probably offers the widest range of effects.

4. DIFFUSERS WITH LENS-LIKE DIFFUSING ELEMENTS. All of the diffusers listed above actually alter the sharpness of the image. Diffusers with bubbles, cross hatches or other irregular patterns produce a sharp image surrounded by a soft secondary image. In extreme situations, the secondary image may be displaced from the primary image enough to create a halo effect that some photographers dislike. Others, who believe that every soft image should have a point of sharpness, prefer them over any other type. While they work best at large to medium apertures, they also work better at smaller apertures than other diffusion filters. Examples are the Softars which are made by Zeiss, and are sold in mounts to fit Hasselblad cameras, as well as others. Although the pattern of the diffusing elements may vary from brand to brand, the Softars, Tiffen's Soft F/X, and Sailwind's Hi-Soft and Pro Soft filters are examples of this type of diffusion filters.

• **Different Effects of Diffusion Filters.** Regardless of the type of diffuser, the purpose is the same – to add a degree of softness that softens hard lines, and minimizes such things as facial blemishes. In addition, diffusion can be used to create a romantic mood and to create a soft and ethereal atmosphere.

Although the purpose is the same, each type of diffuser produces a slightly different effect. For example, Image 86 was made using a Harrison & Harrison #4 Black Dot Texture Screen, which is Harrison's black textured diffuser. This filter is the next-to-strongest filter in a five filter set. Image 87 was made with Harrison's D-4 diffusion filter, which has an overall texture. It is the second strongest in this five filter set. The D-4 diffuses and reduces contrast more than the Black Dot diffuser. The difference between these two filters is dramatic. Which is best? The answer is another question. Which meets the requirements of the portrait you are making? The answer to this question is a matter of personal preference – the personal preference of both you and your client.

If you want to produce a variety of effects, you will find that a single diffusion filter isn't adequate. Instead, you will

IMAGE 86

IMAGE 87

need a diffusion system. Images 88-90 were made with the three Hasselblad Softars. Image 88 was made with a Hasselblad Softar I. The effect of this filter is subtle when used to make a portrait such as this. Under different conditions it may be more dramatic. Image 89 was made with a Softar II, and Image 90 was made with a Softar III, the strongest filter in the Softar series. Which of the three should you use when making a portrait like this? Once again the choice is personal.

IMAGE 88

IMAGE 89

IMAGE 90

Image 88 was made with a Hasselblad Softar I. Image 89 was made with a Softar II. Image 90 was made with a Softar III.

• **Factors That Affect Diffusion.** There are a number of factors, other than the diffuser you select, that affect the results you will get in a soft portrait. According to the late W.H. Harrison, one of the founders of Harrison & Harrison Optical Engineers, those factors are:

1. IMAGE SIZE. If you want a consistent degree of diffusion, a stronger diffuser is required for a close-up portrait than for a full-length portrait.

2. BACKGROUND. A portrait made in front of a brightly lighted white background, requires less diffusion than a portrait made on a darker background.

3. THE FILM USED. Higher contrast films such as the two Portra VC films, require more diffusion to produce results that equal the results achieved when using a film like the Portra NC films and Fuji's NPS 160. Most transparency films are also higher in contrast.

4. PAPER CONTRAST. The contrast characteristics of a photographic paper affect a diffused image. If you print on a paper such as Kodak's Ultra, you will need more diffusion to produce the same degree of softness that you would get using Kodak's Portra paper. The same applies to black and white. If you use a diffuser that reduces contrast dramatically, you may need to use a higher contrast paper.

5. LIGHTING. Both lighting ratios and the shadow edge characteristics of a light source are factors that affect the degree of diffusion. Higher ratios require more diffusion to produce the same degree of softness that a weaker diffuser will produce at lower ratios. A point light source casts a shadow with a sharp edge. A highly diffused soft box, or an umbrella, placed close to the subject, casts a shadow with a soft edge. The sharper the edge of the shadow, the more diffusion is required to produce the same degree of softness that is achieved with less diffusion when using a softer light source.

The best diffusion filters are expensive, but you can produce beautiful, though more limited, diffusion effects without spending a lot of money. Image 91 was made using a Cokin number 1 diffusion filter. Cokin diffusion filters are available in two degrees of diffusion and are less expensive than other major brands. Even the number 1 falls in the extremely soft category, and the number 2 is super soft.

IMAGE 91

You can get started in soft portrait photography with an even smaller investment. Image 92 was made using a diffuser made at home from a piece of black nylon mesh material stretched in a 3" square frame. You can even create a diffusion system by using different types of mesh or by burning a series of holes in a piece of the mesh fabric. Start with one hole in the middle and then make more filters with a series of holes around the center hole. The more holes, the less diffusion.

So far we've been looking at portraits of the same subject, a brunette dressed in darker tones on a low key background. You may want to use a completely different diffuser when photographing a blond dressed in white on a white background. The next two photographs are a comparison between the strongest filters in two very different sets of diffusers. Image 93 was made using a Harrison & Harrison D-5, which is a diffusion filter with an overall texture. This is a very strong filter. In addition, light bouncing off of the white background and around the room increased the effect of the diffusion filter. Image 94 was made using a Harrison & Harrison #5 Black Dot Texture Screen. This type of diffusion filter is affected less by light bouncing off

IMAGE 92

IMAGE 93

IMAGE 94

the background than any other type of diffusion filter. Unless you want reduced contrast and a highly diffused effect, black textured diffusion filters are a good choice when working with a white background.

Regardless of the type of diffuser you choose, you have a choice of several brands. If you start with just one diffuser, pick one that is part of a set so you can go back later and add diffusers of different strengths as your needs and preferences change.

Consider the way the diffuser is mounted. A lens shade, such as one of the Lindahl or Sailwind professional shades with a drop-in filter slot, makes it easier to change diffusers. Sometimes it's hard to focus with a diffuser in place. The drop-in feature makes it easy to raise your filter between photographs, focus and then drop the filter back in place before you shoot. A number of diffusers are available in drop-in mounts. Some manufacturers offer empty frames that accept either 3" square or series-size diffusers. These frames can be used with any brand of filter that is the correct size. With all of the adapters that are available, you should be able to find a way to mount almost any type and almost any brand diffuser in whatever professional shade you use.

Regardless of the type of diffuser you choose, remember this: to produce consistent results under a variety of conditions, or a variety of results when the conditions are similar, you need a diffusion system, rather than one diffuser.

■ Vignetting

Vignetting, which is used to obscure unwanted detail and to focus attention on the primary subject of a portrait, is a technique that goes back to the days of large format black and white portraiture. Before the time of enlargers, all photographs were contact printed to the same size as the negative. Very few manipulations could be made, so the idea of "getting it on the negative" wasn't just desirable, it was a necessity. Modern machine-printing methods have the same effect. You cannot dodge, you cannot burn in. You've got to get it on the negative – and a vignetter can help you do that.

Modern camera vignetters are designed to be used with single lens reflex (SLR) cameras, fitted with longer than normal focal length lenses at medium to wide apertures. If you use a wide angle lens, or stop down too much when using a longer lens, the pattern of the vignetter will show. You can use a vignetter with a normal focal length lens if you avoid smaller apertures and place the vignetter close to the lens. However, you will find that you won't use vignetters with normal lenses very often for studio portrait photography.

• **Matte Boxes.** Old-time camera vignetters were mounted on elaborate gadgets that allowed the photographer to adjust the relationship between the vignetter and the lens of the camera. These cumbersome gadgets have been replaced by specially designed matte boxes that, in essence, do the same thing.

Although matte boxes vary in design, most incorporate a bellows system that allows the photographer to adjust the distance between the vignetter and the lens of the camera. The first professional matte boxes for portrait photographers were single bellows boxes with a rear section that contained a filter slot, and a front standard that held the vignetter. The difficulty with this arrangement was that light could fall on the vignetter. If the vignetter wasn't opaque, the unwanted light created a flare situation that could spoil the photograph.

A two-section matte box has a rear standard which incorporates the lens mount, and a filter slot which accepts square filters, including diffusion filters. It is attached to a section of bellows which connects to the center standard. The center standard has a vignetter slot which is used to hold low key vignetters. A second section of bellows prevents light from falling on the vignetter. It connects to the front standard, which contains another vignetter slot. This slot can be used to hold high key or opaque vignetters.

• **Factors that Affect Vignetting.** There are a number of factors, other than the vignetter itself, that influence the effect you will achieve with any vignetter. They are:

1. THE FOCAL LENGTH OF THE LENS. Vignetters were designed to be used with longer than normal focal length lenses. The exact focal length of the lens or lenses you use for portraiture will depend on the camera you use, the size of your studio and the portrait you are creating.

2. THE SIZE OF THE OPEN AREA OF THE VIGNETTER Vignetters with large openings vignette less, while vignetters with smaller openings produce tighter vignettes when placed at the same distance from the lens.

"... this unwanted light created a flare situation..."

3. THE DISTANCE FROM LENS TO VIGNETTER. The distance between your lens and your vignetter mask also contributes to the effect you will achieve. The closer the vignetter mask is placed to the lens, the larger the picture area and the smaller the vignette. The further the vignetter is placed from the lens, the smaller the picture area and the larger the vignette.

4. THE APERTURE USED. Vignetters are designed to be used at large to medium apertures. The larger the aperture, the larger the picture area and the smaller the vignette. The smaller the aperture, the smaller the picture area and the larger the vignette. Stop down too much and the pattern of the vignetter will show.

• **Low Key Vignetters.** Some low key vignetters, such as the Lindahl Clearflex series, don't have a very distinct pattern. They can be used at smaller apertures than other types of low key vignetters, but even these most forgiving vignetters must always be used with care. The key to good vignetting is to place the vignetter at a position that is far enough out of focus to keep the pattern of the vignetter from showing, and to use an aperture that is suitable.

Certain diffusion filters can cause a problem when used in combination with vignetters. The bubbles or cross-hatched patterns that create the soft effect in filters, such as the Softars, act like tiny close-up lenses. Unless you check the effect very carefully when using them with a patterned vignetter, you may record the vignetter's pattern, even at the recommended apertures. If you want to use a diffusion filter of this type, try a vignetter with a small opening and place it as close to the lens as possible. Use apertures no smaller than f8 and, when possible, make a Polaroid test.

Image 95 was made without a vignetter. Image 96 was made using a 150mm lens with a Leon G2, low-key vignetter that was adapted to fit the center slot of a Lindahl matte box. The lens opening was set at f8 and the vignetter was placed 3-1/2" in front of the lens.

IMAGE 95 IMAGE 96

Image 95 was made without a vignetter. Image 96 was made using a 150mm lens with a Leon G2 low key vignetter that was adapted to fit the center slot of a Lindahl matte box.

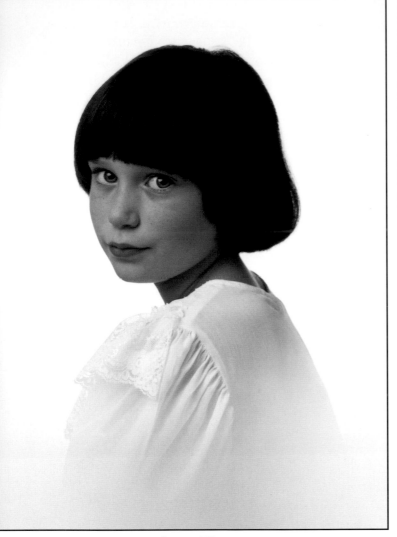

IMAGE 97

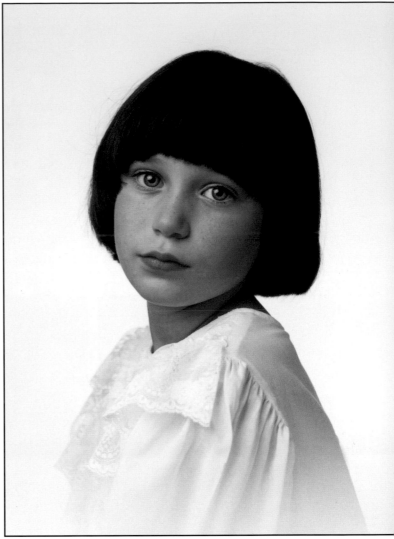

IMAGE 98

There are other types of low key vignetters including vignetters by Sailwind and Lindahl. While some work better than others in certain situations, all were designed to produce similar effects.

• **High Key Vignetters.** High key vignetters were designed for use when the majority of the values in the photograph are lighter than the subject's skin tone. Image 97 was made using a Sailwind Soft Frost vignetter mounted on the front standard of a Lindahl matte box. It was positioned 5-1/2" in front of the camera lens.

You will be able to achieve the cleanest possible high-key vignette if you use a translucent or white vignetter that can be illuminated separately (Image 98). You can do this using almost any vignetter system; however, the Lindahl Hi-Key Vignetter was designed specifically for this purpose. Its no bellows construction allows light to reach both sides of the vignetter. The system includes a small, battery-powered flash unit used to light the vignetter mask separately.

*Image 97 was made using a Sailwind Soft Frost vignetter mounted on the front standard of a Lindahl matte box. You will be able to achieve the cleanest possible high key vignette if you use a translucent or white vignetter that can be illuminated separately (**Image 98**).*

Recycle Time

Remember that the small, battery powered electronic flash may not recycle as fast as your studio lights. Be sure it is at full charge before each shot.

Here is how to use this vignetter system.

1. Set up a white seamless background and arrange your lighting. Image 98 was made using a Larson Starfish as the keylight and a 39"x72" Photoflex Litepanel as the fill.

2. Adjust your lighting ratio as desired. In Image 98, the difference between the keylight and the fill was adjusted to 1-1/2 stops.

3. Use your meter's flat disk receptor. Adjust your background light to read 1/2 to 1 stop more than the keylight. In the case of Image 98, the background light was adjusted to read one stop higher than the keylight. With the Lindahl high key matte box in place, and a small flash unit mounted in its shoe mount, but with no vignetter attached, hold your meter at the spot where the vignetter will be mounted and take a reading. Since this light is placed so close to the vignetter, it may be too strong. If it is, you can reduce its intensity by attaching a piece of lighting grade neutral density gel material over the flash. After you do this, re-read and add additional layers of gel material until the meter reads as close as possible to the background reading. You can substitute layers of diffusion material for the neutral density gels, but gels are calibrated according to density, which makes them easier to use.

4. Put your vignetter in place and stop the lens down to the shooting aperture, while you adjust the position of the vignetter, until you see the effect you want. Whenever you use any vignetter, it is important to make the final adjustments to the vignetter with the lens at the shooting aperture. Try it and you'll see why. As the lens is stopped down, you'll see the vignetted area tighten. In fact, you may find that, even when positioned with the lens stopped down, the vignette is a little tighter than you planned. If you have this problem, you can correct it by moving the vignetter a little closer to the lens.

■ High Impact Close-Ups with a Tele-Extender

Tele-extenders, which convert a normal focal lens into a moderate telephoto, or a moderate telephoto into a really long focal length, were intended to be used for outdoor photography. Very few photographers think of a tele-extender as portrait tool, but when used properly, one will turn the lens you usually use for head and shoulders portraits into an extra-long lens that will allow you to create high impact close-ups that are completely free of distortion.

This close-up portrait (Image 99) was made using a 150mm lens, focused at four feet, which is as close as it will focus. You could move closer by attaching an extension

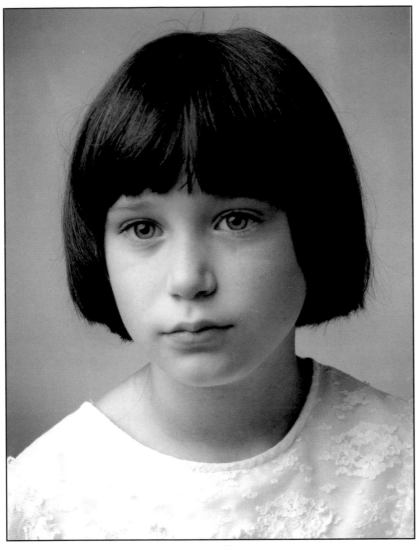

IMAGE 99

*The close-up portrait shown in **Image 99** was made using a 150mm lens, focused as close as it will focus.*

tube, but because you are so much closer to your subject, your image would be distorted. You will get a larger head size if you switch to a longer focal length lens, but because longer lenses don't focus as closely, you may not get the extreme close-up you want. If you attach a 2x tele-extender to your 150mm lens you will find that you can still focus to a distance of four feet. This means that, just by using a tele-extender, you can create distortion free, frame-filling head shots such as Image 100.

A two stop exposure compensation is required when using a 2x tele-extender. When working close, you need more depth of field, rather than less, so instead of opening your lens, increase your strobe's power. Use an aperture of f11 or smaller when creating head shots like the one shown here. If your strobes aren't powerful enough, switch to a faster film. You can use an ISO 400 speed film with a tele-extender at the same aperture as a 100 speed film without the tele-extender. A few years ago, switching to a faster

"... it doubles the focal length of a lens..."

color film might have meant excessive grain and poor resolution. Today, the grain structure and sharpness of fast medium format films, in both black and white and color, are equal to that of slower films from just a few years ago.

The beauty of the tele-extender is that it doubles the focal length of a lens without changing the closest focusing distance.

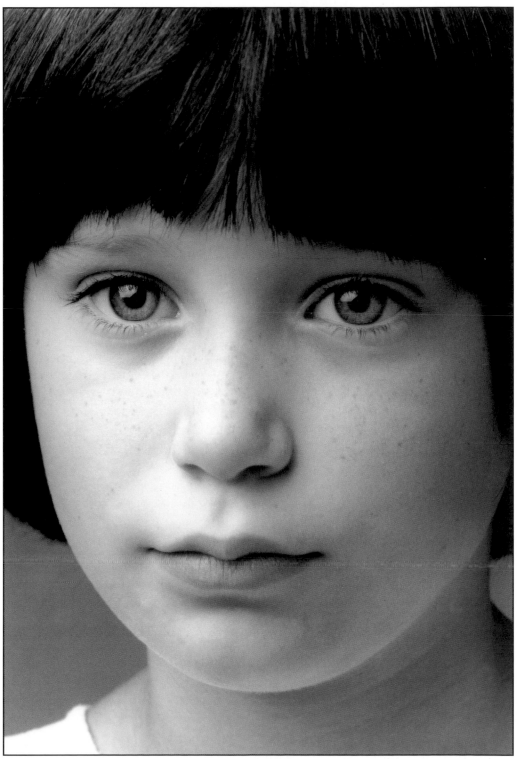

IMAGE 100

6
Psychology of Portraiture

■ Introduction

Photographic technique is important, but technique is not the most important element in a portrait. The person in front of the camera is. The best portraits are those that make a statement about the subject. Saying something really significant in a portrait isn't easy, but it can be done. Just look at the portraiture of Phillipe Halsman, Yosuf Karsh and Arnold Newman. Unless you establish rapport with your subject, you have very little chance of creating much more than a quickly done, mass-market portrait. Rapport is something that you can't learn by looking at a diagram or following a step by step guide, but it is something you must think about.

■ Rapport: The Art of Working with People

If rapport is so important, how do we go about establishing it? First, it may help to understand just what rapport is. According to the dictionary, rapport means having a sympathetic relationship with another person. As it applies to photographic portraiture, rapport is the thing you establish when you give a child a few minutes to realize that you are a playmate, not someone who gives shots. Rapport is what you continue to build as you play with and entertain that child all through the portrait session.

Establishing rapport is equally important in every area of portraiture. Cameras can intimidate even the toughest executive or the most beautiful woman. In your imagination, put yourself on the other side of the camera. How does it feel? It can be intimidating, even to someone who is totally familiar with the portrait process. The photographer's style, not just of photography but of working with people, can

> "Saying something really significant in a portrait isn't easy..."

turn an ordeal into a pleasant experience, or it can do just the opposite.

• **Learn Your Subject's Interests.** The best way to establish rapport is to find some area that interests your subject. The man shown in Image 101 is a multi-talented individual. He is an audio and video expert who, in addition to his regular job, plays guitar and works as the straight-man in a comedy act. A musical instrument can be more than a prop to be used in a photograph. It can become a focus for conversation. You can't know enough in every area to talk intelligently, but you can know enough about many things to ask questions. Never be afraid to flaunt your ignorance. It can save the day.

• **Provide a Distraction.** There are other tools that will help you establish rapport, or at least create a comfortable atmosphere. A speaker at a seminar suggested this: when you are photographing someone who is nervous about the process, start out by stumbling over some piece of your equipment. The speaker said that if you repeat this just a few times, your subject will think "If this poor oaf can get through this, I surely can." Did he mean for you to take this advice seriously? Probably not, but it does illustrate a principle. Get your subject to think about something, almost anything other than his concern about the portrait session.

• **Music.** Another way to distract your subject from the portrait process is to play music. Most of us like some type of music, but what we like isn't particularly important. Try to broaden your interests and, as your appreciation for different kinds of music grows, add to your collection of tapes or CDs until you have something that will work for everybody.

Sounds are probably the best tools you can use to establish rapport. Conversation and music are obvious choices, but there are others. Try recorded poetry or even comedy records. In Chapter 7 you'll read about an experiment using recorded poetry to create mood, and about how a good cigar helped break the ice during an important portrait session.

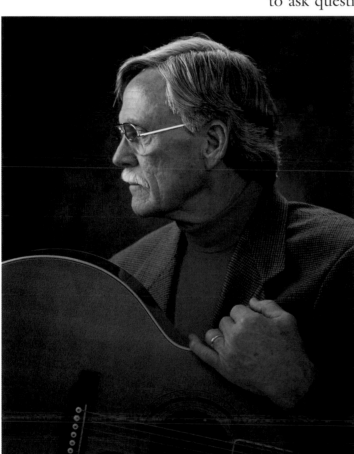

IMAGE 101

Author's Note

When all else fails, do what I do in times of desperation – talk about what you are doing. Explain that you want to make the background lighter or need to check the light balance. It isn't exactly stimulating conversation, but it fills that

Portrait Gallery: Learning by Example

■ Introduction

This chapter is different from the ones which have preceded it. Each "lesson" that follows is a personal observation concerning an actual portrait session. Each section is designed to reinforce one or more of the lessons from the first part of the book. These photographs weren't made as teaching tools. I seldom take notes during a regular portrait session, so I haven't provided all of the technical details. If you learn to read the photographs as well as the text, this may be the best part of the learning experience that I can offer you.

■ Image 102: Capturing Your Subject's Personality

How do you capture a person's personality in a portrait? First, you need to know something about that person. This man started out working on an assembly line and worked his way up to plant manager of a major manufacturing facility. I photographed him back in the 60s. I wanted to show him as the strong and decisive leader that he was. It didn't take long for me to realize that this man, whose reputation was that of a tough manager, was like a lot of other people when it comes to confronting a camera. It wasn't easy for him.

I had worked around his plant on commercial assignments and met him several times before I made this photograph. I knew that there was nothing he loved more than a good cigar. Before the session, I went to the drug store and bought their biggest, best and most expensive cigar, one of those in a fancy glass case. As we were getting started, I gave him the cigar. Talking about cigars isn't exactly intellectually stimulating, but it proved to be the perfect ice-breaker.

"... learn to read the photographs as well as the text..."

To be honest, I had no real expertise about cigars. Even though I was a smoker at that time, my taste in cigars ran more to ten cent Swisher Sweets than $3.00 monsters in glass tubes.

I went through a series of head and shoulders poses. When I reached the point where I wanted to do the portrait that would define him, at least as I saw him, I invited him to light up. Note the perfect ash on the cigar. In the relaxed atmosphere that I was able to create, he relaxed and allowed me to direct him into a pose that I believe shows strength, determination and leadership. Everything else was designed to project that same image. The simple set is supposed to represent an office. The lighting is strong, masculine lighting – 45° from the short side with deep, but detailed shadows. I made this photograph 34 years ago, yet it's still one of my favorites.

In those days I used a 4x5 portrait camera, fitted with a 12" Kodak Commercial Ektar lens for most of my studio portraiture of adults. My keylight was a Photogenic Flashmaster with a 16" parabolic reflector. Although the techniques aren't what I use today, I don't see anything dated about this photograph.

IMAGE 102

■ Image 103: Business Portrait with a Challenge

This is a publicity portrait I made a number of years ago. Doing a businessman's head shot can be a cut and dried proposition, but not this time. My subject's glasses were so heavily corrected that I couldn't avoid reflections and still light the portrait satisfactorily. Since his glasses were a part of him, I wanted to keep them in the photograph so I asked him to hold them in his hand. His right eye, which was bad, was a more serious problem. I had to hide it, but I wanted to do it in a natural way. I chose this pose, a semi-profile, rather than the standard 3/4 pose. I used split lighting from the broad side of his face, which illuminated his left eye satisfactorily, while leaving the right side of his face in a shadow.

A man's ear is never his best feature and a balding head can always be a challenge. Since this portrait was in black and white, the solution was simple. When I made the print, I burned in the right side of his face and the top of his head just enough to tone down those areas. The same effect can be created when making the negative by using a flag, a scrim or barn doors attached to a parabolic reflector. In this case, solving the problem in the darkroom was simpler. The important point is not *how* the problems were solved, but *that* they were solved.

IMAGE 103

■ Image 104: The Story of Little Phil

This is a true story from years ago. Little Phil's mother, a single Mom, was one of my customers. When she remarried, she called me about photographing her wedding. I was already booked so I recommended a good wedding photographer in her part of town.

She was pleased with the job, so when it came time for Little Phil's next portrait, she went to her wedding photographer. Phil's Mom explained that what she wanted was a plain portrait of little Phil – no props, no gimmicks, just Phil as he really was.

The photographer was confident that she knew best, so she went ahead and photographed Phil with the assortment of props that she usually used. As it turned out, what Phil's Mom *really* wanted was a plain portrait of little Phil.

She called me and asked if I would do a plain portrait of Phil. I told her that of course I would, and then I asked what a plain portrait was. My first thought was that she wanted an old fashioned head and shoulders portrait, but that wasn't it. She explained that what she wanted was just a portrait of Phil, dressed in his regular clothes and being himself.

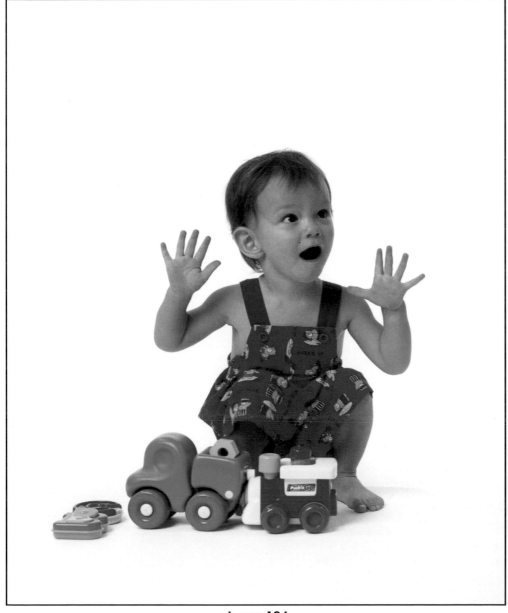

IMAGE 104

I made a plain portrait of little Phil. I didn't use any props, just whatever Phil brought with him. She was pleased and she continued driving all the way across Atlanta to bring Phil to us for years.

The child you see here isn't Phil. Finding the negatives from Phil's session, which was in pre-computer days, would be too much of a challenge. However, this portrait, like Phil's, is a plain portrait of a real kid busily being himself. His name is Yuuki and he is all boy. His aunt saw one of my off-site displays with the slogan, "We photograph real kids." She called to ask what that meant and I explained. She liked the idea and brought Yuuki in for a session.

If I were a "rule book" photographer, I would be happy to sell this portrait to my client, but I probably wouldn't show it as an example of my best work. His face is turned away from the keylight, leaving it in a shadow. The shadow is open and has full detail, but Yuuki's portrait still violates the rule that the most important part of the subject should receive the most light. But I am

not a "rule book" photographer. I am proud to show Yuuki's portrait and claim it as one of my best. The photograph is spontaneous. It shows Yuuki doing something that, according to his aunt, is very characteristic of him. The shrug, the upraised hands – there is nothing I could have done to get Yuuki, at his age, to do that. Area lighting, a camera that didn't require a lot of between-shots attention, and good reflexes made this portrait possible.

Little Phil's photography session was a valuable lesson about listening and finding out what the customer wants. This lesson was repeated just recently. The mother of a high school senior from the other side of Atlanta called on the recommendation of a friend. None of the yearbook portraits of her son fit her definition of a senior portrait. Would I do one? This was a switch for me. Years ago I built a good business among seniors from area high schools by doing portraits that weren't the traditional "drape/tuxedo, three shots facing this way, and three facing the other" headshots. Now it was my turn to do a switch and make a "plain portrait." I did.

■ Images 105-107: A Storytelling Sequence

Sometimes there is a visual story that can be told through a sequence of photographs better than it can be told through one image. These three portraits show my fifteen month old grandson climbing up on a kitchen stool in my studio. Adam likes this stool. He'll pass up a high chair or most anything else to sit on it. If he just happens to see it, he'll climb it. We took it to the studio for Adam's portrait session, set it up on our white background, and turned Adam loose. That's all we had to do. Adam did the rest. We used an area lighting set-up and illuminated the background with two Balcar P System lights. I used a Larson Starfish as the key-light with a Photoflex Litepanel fitted with white fabric as a fill.

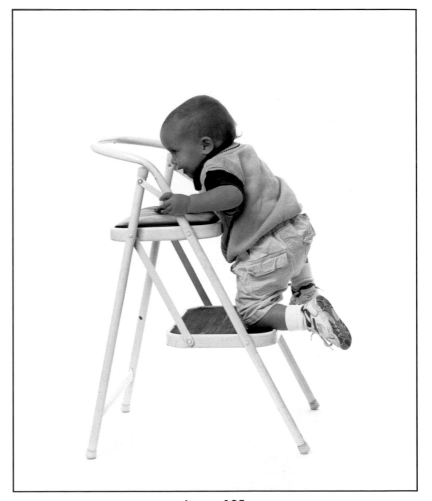

IMAGE 105

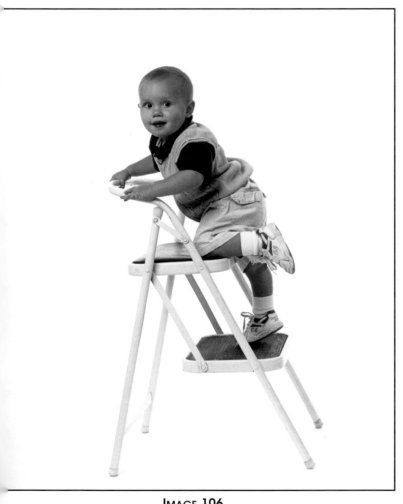

IMAGE 106

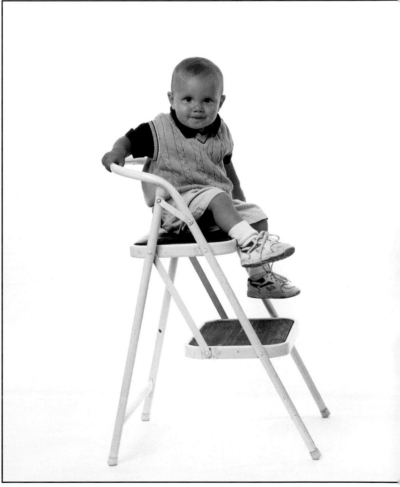

IMAGE 107

■ Images 108-109: Children are Always Changing

Children are constantly changing. Be ready for those changes because they will affect the way you work. My granddaughter is in her second year of dance lessons and she loves it. Last season we had a plan for her dance photography session. We knew exactly what we wanted and we knew she could do those things. What we failed to realize was that Anna had a different plan. She loved performing so much that she decided that picture time was really show time. Her mom took her to our dressing room, dressed her in her tap costume and turned her loose. She skipped out to the shooting area, ran through part of the performance and skipped away before I could explain what I wanted. After a couple more tries, I realized what Anna was doing. She wasn't posing; she was performing. Each time she skipped off the background paper, she went back to the dressing room again, skipped out and put on another show. Once I realized that I wasn't supposed to direct, that all I was supposed to do was take photographs, things went better (Image 108).

This year we expected a repeat of last year's performance, but that wasn't to be. During the past year, Anna

> "She wasn't posing; she was performing."

IMAGE 108

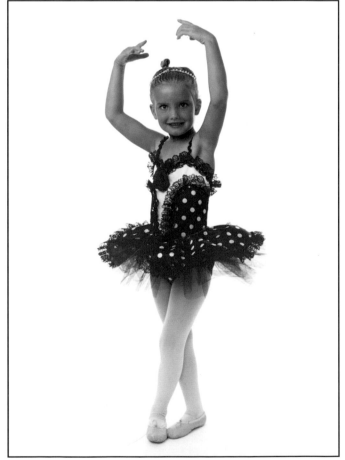

IMAGE 109

has learned poses that are at least an approximation of the traditional ballet positions. She ran through them for me. The pose in Image 109 is almost, but not quite, grown-up perfect.

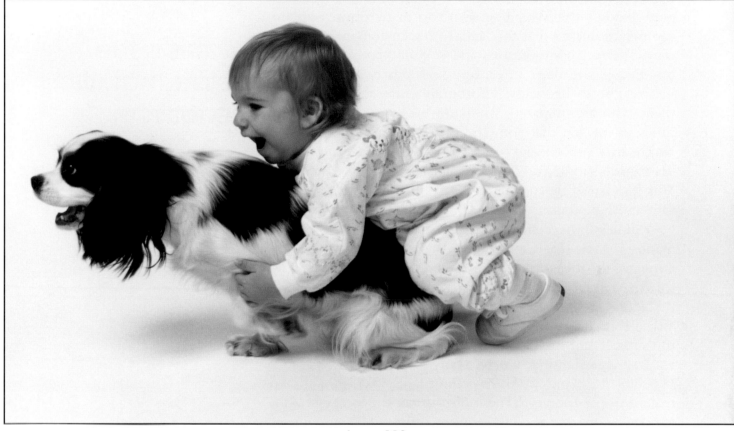

IMAGE 110

■ Image 110: Candid Portraits of Children

I like to talk about photographing real kids. When you photograph a real kid, you have to settle for what you get. I am sure that my client didn't pre-visualize this portrait. Whatever she did pre-visualize involved a child in pajamas. Maybe she thought the child and the puppy would play quietly together. That didn't happen.

This was my second session for this family. The first was a family portrait with all of the children and their collection of King Charles Spaniels. The older children held some of the dogs and we put others on blocks that were tall enough to make the pups hesitate before jumping. Everything went along smoothly, or a least as smoothly as that sort of session goes. Nothing about that first experience prepared us for this particular child and this particular pup when they were left on my seamless background to play together.

In the middle of the chaos that followed, the puppy decided to leave and almost reached the edge of my back-

"Nothing about that first experience prepared us for this particular child..."

ground before his mistress captured him. At a time like this, you don't plan, you don't tell yourself to shoot. Nothing goes through your mind except the recognition that something is happening, and without even stopping to hope for the best, you trip the shutter. Do things like this just happen? I don't think so. I've seen too many photographers capture moments like this and I've seen too many others create perfect compositions and seldom capture a slice of real life. If you want to capture real kids doing real stuff, you've got to be ready. Photographs like this happen to those who are prepared. Thinking back and analyzing the times in my life that something like this has happened, I realize that you seldom recognize exactly what is going on before you shoot. You don't think through the possibilities. You just know that something is brewing and you shoot. Otherwise, you don't get it.

I didn't try to center the subjects when having the print made. I think that the position of the child and the pup reinforce the idea of the dog running away. I cropped to the format I selected because I feel that this is the shape that fits the action in the photograph. It also fits my belief that the "ideal format" is the format that best follows the shape of the subject and the direction of the action.

Use area lighting and be ready to shoot fast. I used a Hasselblad EL and my fast recycling Balcar A 1200 lights to make this photograph. The motor drive, the long electronic release cord and the "shoot now, compose later" convenience of a square format camera left me with only one responsibility – to catch my two subjects somewhere on my seamless background. Reasonably good reflexes took care of this.

This photograph was made on VPS. Not too long after it was made, I discovered Vericolor HC, the higher contrast version of VPS, and switched over for the cleaner whites and brighter colors it produced. If I were doing this session today, I would use Kodak's Portra 160 VC.

■ Image 111: Kids – Their Way and Mine

On page 77 (Image 86) I showed you a casual, almost self-posed portrait of a group of children. Image 111 is another. This portrait is a combination of my ideas and the ideas of the kids in the photograph. I have had more positive responses to this portrait than to any portrait of a group of children that I have ever displayed. Although my technique and the quality of the print were good, I don't think anyone noticed. *Everyone* noticed the kids. And isn't that what we are supposed to do – show off the people we pho-

"... this is the shape that fits the action..."

tograph, not our skills? I like photographing real kids without a lot to distract from them. Is my way the best way? Not necessarily, but it is my way, part of the concept of photography that I have developed over the past forty years.

IMAGE 111

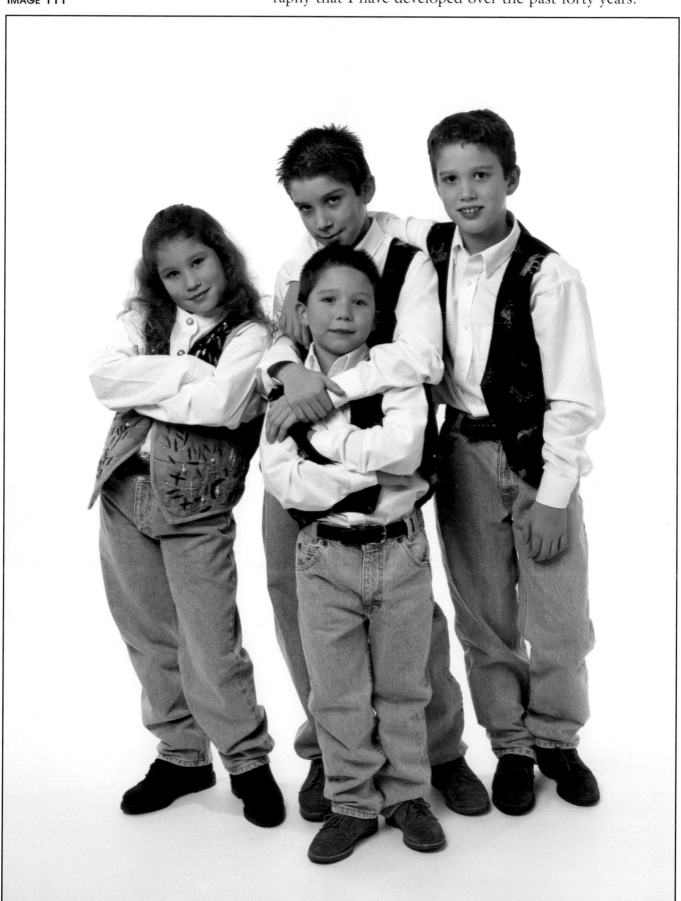

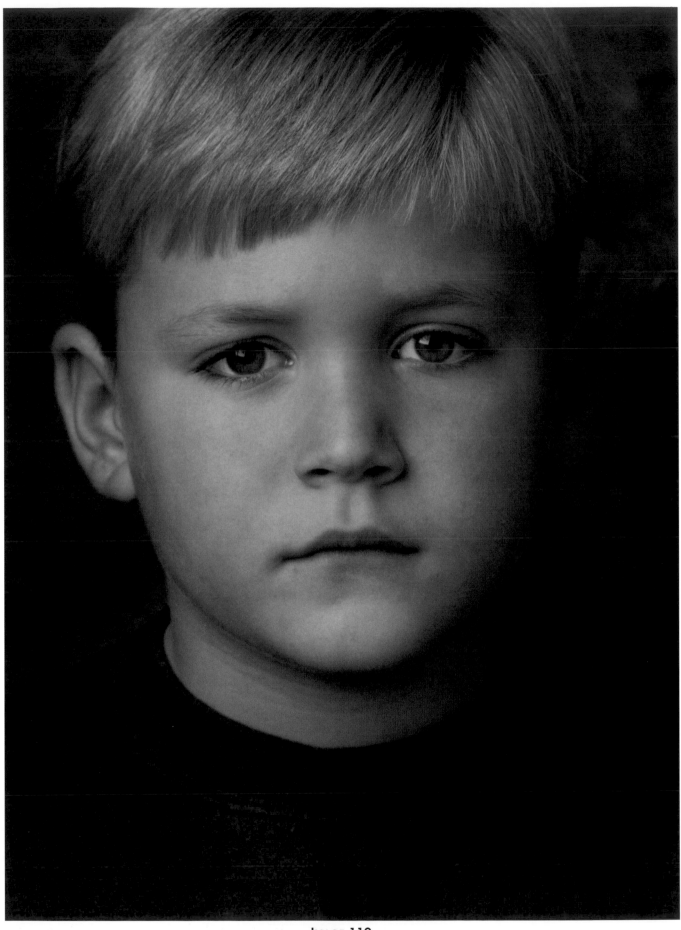

IMAGE 112

■ Image 112: The Greatest Challenge

One of the recent trends in portraiture has been toward a portrait as part of a scene – lots of space around the subject and lots of scenery or studio props. We see this most often in outdoor photography, but we run across it in studio work as well. I love this kind of photography, but I don't see it as particularly challenging – at least not when compared with a close-up portrait that captures something about its subject. There is nothing in a close-up to distract the viewer from any mistakes you may have made. Your lighting must be good, but most of all you must make contact with your subject. Image 112 captures Garrett at a serious moment. I made it using my Hasselblad EL, a 150mm lens and a 2X tele-extender. (For more on close-up portraits with tele-extenders, see Chapter 5.)

■ Images 113-114: Pets Have Personalities, Too

Pets are just like people. They have personalities and the differences in their personalities create different photographic possibilities and present different challenges. The photographs of these two dogs, and the account of their photography sessions, point out those differences.

Prepare for a portrait session with a pet as you would prepare for a child. Set up as much as possible in advance. My subject for Image 113, a West Highland Terrier, was a small dog. I set up a posing table that is just high enough to discourage most small animals from jumping. I covered the table with gray muslin. I hung a darker muslin background and lighted it just enough to keep it from photographing as a dead black. It is easy to lose detail in a white animal, so I rigged an accent light (a LiteLight lamphead fitted to a 16" parabolic reflector) on a boom and suspended it over the table. I set up my keylight, a Larson Starfish, at a 45° angle to the subject area. I placed a reflector flat on the

> "There is nothing in a close-up to distract the viewer from any mistakes..."

IMAGE 113

other side of the set-up to act as a fill, and adjusted the intensity of the accent light until it was one stop more intense than the keylight. With the set-up complete, we brought the Westie in the studio, put him on the table and made a few minor adjustments in the lighting. I made a few shots and then I decided that the area under his chin was too dark. I added another reflector, a Photoflex Litedisc which was set up in front of the dog in the kick up position.

How did we get the dog to react with such an alert expression? Pet specialists have a bag of tricks that they have acquired by studying different species and breeds of animals. I'm not a specialist, and I don't know all the tricks a specialist knows, but I have found that I can usually do about as well as a specialist with the help of the dog's owner. This owner knew exactly what would capture her pet's attention – peanut butter M&Ms. I asked her to stand at the place where I wanted the dog's eyes and offer him an M&M. From this point on, it was easy. He would follow every movement she made with his head and eyes. Otherwise he remained frozen in place.

I used a Larson Starfish as a keylight and a 3x4" Photoflex Multidome as a fill when I made this portrait of

"This owner knew exactly what would capture her pet's attention..."

my daughter's Greyhound, Quattro (Image 114). Our initial idea was to make a formal standing pose. We thought that maybe, just maybe, we could get him to stand alertly in place for a few exposures, but every time we removed his leash he moved closer to my daughter. We were about to give up when we thought about what Quattro really does – he rests! We moved a wicker love seat into the studio, tossed a throw over it and led Quattro to it. Without hesitation, he jumped up and promptly settled down. Although this was not the portrait we set out to make, it was the one that shows us the Quattro we know.

These two pet portraits show us that dogs, like people, have their own very different and unique personalities. My experience has shown me that pet portraits, like children's portraits are easier to do if we work with the animal as he is, and not as we might pre-visualize.

IMAGE 114

■ Images 115-116: Two Ways to See Three Sisters

There are many different ways to see people. These three sisters are about as different as three young women can be. I wanted to try to capture that difference. I asked each to dress in a way that she thought expressed her personality. One, a successful business woman, dressed the part. Another, whose hobby is writing songs and poetry, is a more dramatic personality. She chose an outfit with a Chinese influence. The third chose dressed-up casual. (Image 115).

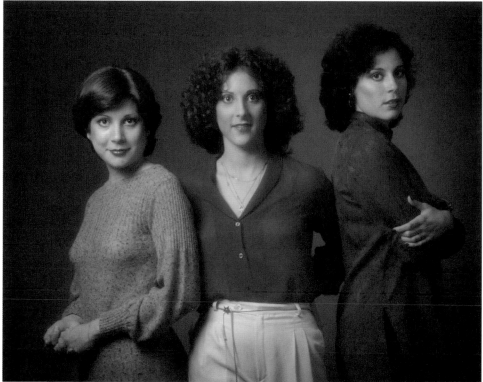

IMAGE 115

My next idea was to create a portrait that, as nearly as possible, would be timeless. Some years ago this might have meant a studio drape. I never liked drapes, but I wanted to create something that would be at least as timeless as a piece of velvet. The pose I planned was a very discrete, nothing-really-showing, nude (Image 116). This portrait is the second of the "non-portrait" portraits that I mentioned in the section on developing your own concept of portraiture. I wasn't at the convention where it was judged, but a friend told me that one of the masters who judged this print selected it to comment on at a print critique after the judging. He said that he suspected that I was influenced by an early piece of art called "The Three Graces." I would hate to

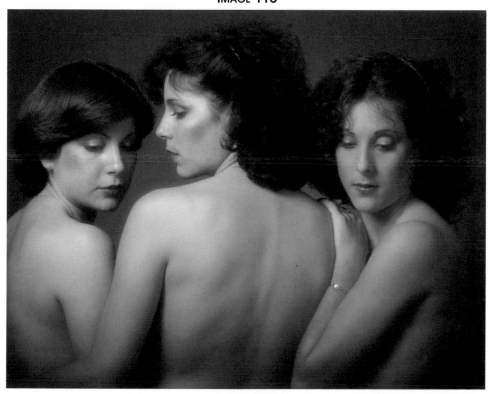

IMAGE 116

disappoint him, but he was wrong. I am familiar with that work of art, but nothing about it entered my mind when I photographed the three sisters. In fact, I don't think that either painting or sculpture has been a major influence on my photography. Instead, I am most inspired by the work of other photographers, by music and by literature.

Every person has different characteristics, we might even say different personalities. Think about one of your customers. How many facets of this person's personality have you seen? How many have you photographed? Try creating two or more very different portraits of one person. I remember one young woman I photographed many times. Once, when looking at a new series of portraits, she said over and over, "Is this really me?" It wasn't that I had flattered her. I just showed her a different side of herself, one she only suspected existed.

■ Images 117-119 : Portraits That Tell a Story

A storytelling portrait can be a professional statement or it can be a personal statement. Images 117 and 118 show two performers whose music and image are very different. The background, the poses and the subjects' expressions say something about the kind of music each makes. The subject of Image 117 is a gospel singer. The subject of Image 118 is a rap artist. One pose and expression suggests reverence. The other pose and expression suggests the anger that is a trademark of many rap performers.

The statement this portrait makes is personal (Image 119). It shows a woman whose life hasn't always been easy, but more than that, it is a portrait of a woman who lives

IMAGE 117

IMAGE 118

IMAGE 119

what Theoreau called an "examined life." Although it is an unconventional view, it says as much about her as any full-face portrait could.

■ Image 120: Finding Portrait Ideas

Where do portrait ideas come from? I had lunch with these two young women after a photo session in the dance studio. During lunch, one of the girls was talking to the other about a recent career disappointment. The other tried to help her put the experience in perspective. I thought that there ought to be a way to make a visual statement which would illustrate the concern and caring I had observed. This photograph (Image 120), which was made in my studio a few weeks later, is my attempt to translate a verbal expression of friendship and caring into visual language.

This situation called for a dark, moody setting, soft light and a soft image. I used a sheet of vinyl floor covering that

"Where do portrait ideas come from?"

was painted a neutral brown as a background, an umbrella as a keylight, and two reflector flats as fills. I used a Hasselblad Softar III to soften the image.

Keep your eyes and ears open for photographic ideas, and once you have the idea, think the picture through, deciding what techniques you can use to enhance the mood you want to capture.

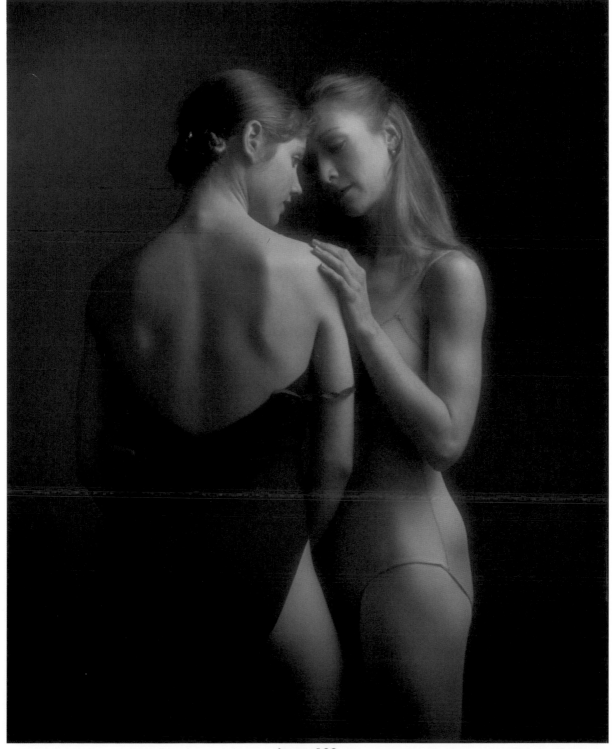

IMAGE 120

■ Images 121-122: Try Poetry to Set the Mood

Establishing rapport with your subject can be a challenge. (Refer to Chapter 6 for more on this topic.) Talking about some common interest is the best way to establish rapport, but sometimes it's hard to find that common ground. Music is great. I have a stereo system in my studio that is almost as important as my cameras, but may not produce a specific response as well as recorded poetry. If you can find poetry on CDs or tapes that fits the mood you want to capture, it may be just what you need. Here is an experiment I tried back in the 70s.

At the time that I performed this experiment, many of my portraits were of women and almost all of them were made for a man. My goal, in this part of my work was to capture more than a physical likeness. I wanted to capture a look that would say something special to the man who would receive the photograph. I talked to several friends about what I was trying to do. One suggested playing recorded poetry and loaned me a set of records. These particular poems were written as if the writer were speaking to a woman.

I tried the idea out during a Saturday afternoon practice session with a model I worked with often. I made up a scenario that involved her being in some romantic setting with some special man. I asked her to project herself into that situation and to pretend that the man she was with was saying the things the poet said. Her response was far more realistic than I imagined it could

IMAGE 121

110

be. I don't know how much was genuine feeling and how much was good acting, but whatever it was, my images seemed to capture something very close to real emotions. Images 121 and 122 are two photographs that were part of my experiment.

I did very little directing during the session. I moved around to capture different angles and, for the most part, kept my mouth shut. The photographs I made are her responses, not my ideas. Admittedly, this was a practice session using a friend who was a professional model as a subject. However, after the success of this experiment, I used recorded poetry often and never failed to get at least one image that seemed to be a genuine response.

I don't know if this would work as well today as it did in the 70s. Times and people change. Try it if you choose, but what I really want to get across is the idea that you should work just as hard to learn the psychology of portraiture as you do the art of lighting.

IMAGE 122

■ Image 123: A Love Story

Occasionally we get to re-create something very real in our studios. The people in this photograph (Image 123) are friends of mine. Their marriage was a second marriage for both of them. They both felt that they had made mistakes the first time and wanted to learn from those mistakes. During their courtship, they spent a lot of time sitting at her kitchen table, talking and trying to foresee and work out problems in advance. She asked me if I could create a portrait that would tell this story.

The first thing I did was not photographic. I put a tape in the stereo and turned it on. Next, I set up an adjustable posing table in front of my brown vinyl background. I asked them to sit across from each other on two posing stools. I used soft lighting and I diffused the image with a Harrison & Harrison D-3 diffusion filter.

"Occasionally we get to re-create something very real..."

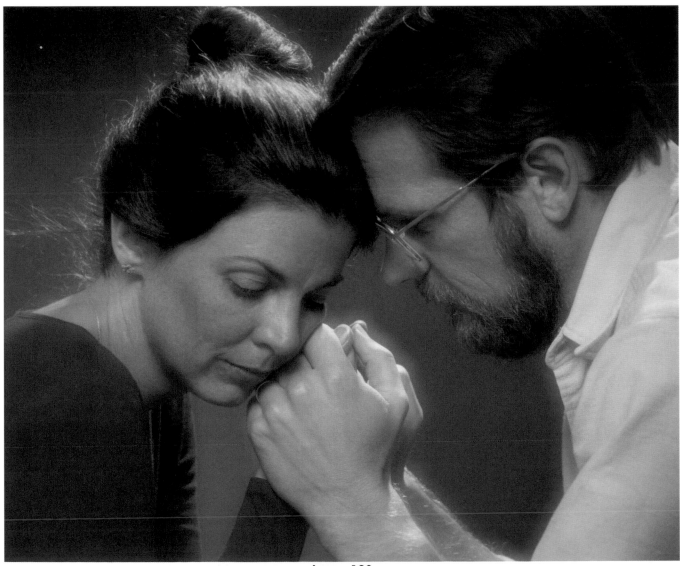

IMAGE 123

With music that fit the mood playing softly in the background, I suggested that they hold hands and remember one of those times. Beyond that, all I had to do was watch and wait as this evolved.

I have had a lot of response to this portrait. I have used variations of this pose many times, including a portrait of a couple (a singer and a musician) that was used on their CD cover. I displayed this print with good effect at a local cafe during a special Valentine's event. One of the customers I acquired from this display is a writer. I made photographs for the dust jackets of two of her books. In addition, I have photographed her family every other Thanksgiving from the time we first met. Just one portrait, if it is the right portrait, and if it is seen by the right people, can bring you more business than you might expect.

Try to re-create some special moment for one of your clients. If your image is successful, be sure people see it. Although you may never meet another person who needs a portrait exactly like it, the fact that you did something different, something that rings a common bell, can make your reputation.

■ Image 124: How Many Lights Does it Take?

We've discussed lights and lighting. We've talked about keylights, fill lights, etc. How many lights does it really take to create a good portrait? I made the portrait shown in this section using a 56" soft white umbrella. The diameter of the umbrella is considerably larger than the head and shoulders area that I needed to flood with light. I used no reflectors, accent or background lights. I just pulled the umbrella in as close to the subject as I could without getting into the picture area. I moved the background closer than usual to the subject so that light from the keylight would spill onto the background.

"I used no reflectors, accent or background lights."

I made four exposure readings, the first for the keylight, the second for the shadow side of the face, the third for the background and fourth for the exposure. The first reading was made with the meter aimed at the keylight, the second with the meter at the shadow side and aimed straight ahead, the third at the background position, and the fourth with the meter aimed from the subject position toward the camera.

I like this portrait (Image 124). I like it a lot. I like the way the light places the strongest emphasis on Kathryn's face. I like the shape of her face, though all I can claim credit for there is that I didn't mess it up with conflicting shadows. I like the soft, glowing, specular highlights. I like her

expression. It's pleasant without being overdone. I like the gentle curve of her throat.

One of the things that contributed to the technical quality of this portrait was the diffusion filter I used, a Lindahl Soft Rings 2. The Lindahl Soft Rings 2 is a concentric circle diffusion filter. (Review Chapter 5 for more on diffusion filters.) This type of diffuser is aperture sensitive, which means that it is softest at large apertures and diffuses very little at small apertures. At f8, the aperture I used when making this portrait, its effect is subtle, what has been called a "soft sharpness."

The thing I like most is that this is a simple photograph, so simple that I am almost afraid to include it in this book, afraid that you won't see what I saw and that you may not like what I like. What I like best of all is that, before I see any of the technical stuff, I see Kathryn.

"It's pleasant without being overdone."

IMAGE 124

Conclusion

"There is always something new to learn in photography..."

If you are new to portraiture, I hope this book will help you get off to a good start. If you are more experienced, I hope you found something of value. There is always something new to learn in photography, at least that is the way it is for me. Whether you are a beginner or more experienced, remember that reading the book isn't enough. Try the lighting set-ups, run the tests and think about the people issues we considered.

I can't close without saying thanks. First, to my wife Evelyn, who has been my in-house editor as long as I have been writing. She was my spell-checker before computers, and she still catches the errors the spell-checker misses.

Although there is no substitute for personal experimentation and practice, there has to be a starting point. There are a great many people I need to thank for leading me to that starting point. In fact, there are so many that I hesitate to single anyone out. However, I must thank all of my "Saturday" models, from the 60s to the present. You probably taught me more about photographing people than anyone else.

I want to thank Heather Stokes at HS Photo Processing in Atlanta, who printed most of the color illustrations in this book, and Claude Shell of CPQ Photographic Imaging of Cleveland, TN, for his personal attention when I needed a few more prints quickly. I have to take the blame for the black and white illustrations. I printed them myself in my own darkroom.

Most of all, I want to thank you, the reader, for considering what I had to say.

Appendix

■ Film Test Form

Is the manufacturer's rated film speed the true speed? Some lab professionals still say that it is a good idea to run your own tests, using your own equipment, and to determine your own personal exposure index (PEI). This makes sense. Regardless of any considerations concerning the film, all cameras, lights and exposure meters aren't equal. If you would like to run your own tests, copy the film test form on the opposite page, then follow the procedure detailed on page 11.

■ Posing Circle

You may find it helpful to imagine that your subject is standing within a circle and that the center of the circle is the weight bearing point which we will call the base point. In the beginning you may find that it will help if you use a real circle, drawn on a piece of poster board or scrap background paper. On page 118 you'll find a larger copy of the posing circle first shown on page 67. If you choose, you may copy it and have it enlarged so that you can use it during practice sessions. For more detail on using the posing circle, refer to the discussion on page 67.

Film Test Form

Test Description:_____

Date:_____ Subject:_____

Camera:_____ Film:_____

Photo#						
1						
2						
3						
4						
5						
6						
7						
8						
9						
10						
11						
12						

Notes:_____

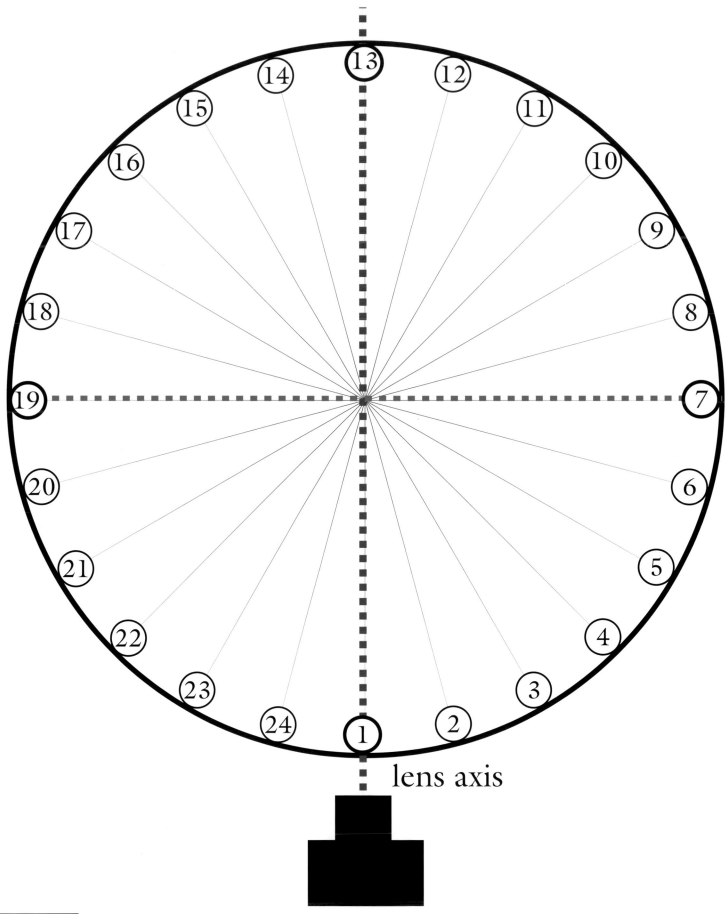

lens axis

Glossary

Accent lights: Additional lights added to a lighting set-up to accent various elements in the scene. See also Hair light and Kicker.

Aperture: The lens opening which is controlled by its diaphragm. The aperture is one of the tools used to control exposure and plays a major role in determining depth of field.

Area lighting: A lighting strategy in which an entire set is illuminated (as opposed to lighting only the subject). This strategy is especially useful for photographing subjects in motion (such a children and pets).

Background light: The light that illuminates the background. Its main function is to separate the subject from the background.

Box and cable lights: A type of studio light where individual lights are all linked to, and powered by, a single power source.

Broad lighting: A lighting pattern created by posing the subject in a 2/3 or 3/4 view and directing the keylight at the side of the face closest to the camera.

Burning: Increasing the amount of light that hits the photographic paper when making a print. Darkens the areas burned.

Butterfly lighting: A lighting pattern created by lining the keylight up along the the subject's nose axis, then raising the light until the characteristic "butterfly-shaped" shadow appears under the subject's nose.

Composition: An effective, pleasing arrangement of lines, shapes and colors within the picture format.

Contrast: Contrast is the difference between the darkness of one tone and another. High contrast occurs when there is a great difference (such as the difference between black & white). Low contrast occurs when there is little difference (such as the difference between medium gray and light gray).

Cropping: Using only part of the image recorded on the film in order to enlarge part of the image or to improve the composition.

Densitometer readings: Readings used to determine the density of a negative. These standardized readings are useful when running exposure tests.

Depth of field: The range of sharpness in front of and behind the focused distance that is considered acceptably sharp in the final image. Depth of field is increased by reducing the size of the lens aperture.

Diffusion filter: A filter which can be used in portraiture to soften hard lines and reduce the appearance of facial blemishes.

Dodging: Reducing the amount of light which hits the photographic paper when making a print. Lightens the area dodged.

Electronic flash: A source of light that can be used alone or in combination with daylight, as both have the same color temperature.

Enhanced color film: Provides vivid colors and enhanced contrast (when compared with natural color films). Can help to maintain good contrast when creating portraits with a soft focus filter. See also Natural color film.

Exposure: The amount of light allowed to fall on the film. Specifically, it is the intensity of the light (controlled by the aperture, or f/stop) and the duration of time the light hits the film (controlled by the shutter speed).

Exposure meter: A device that measures the amount of light that falls on or is reflected by the subject, and provides a selection of shutter speeds and aperture settings that will allow the correct amount of light to reach the film. An exposure meter can be a hand-held meter or it can be built into the camera. See also Incident meter, Reflected meter and Spot meter.

Fill light: A light source used in addition to the main light to illuminate dark or shadowed areas. An additional light or reflector can be used as the fill light source.

Film sensitivity: Indicates how sensitive the film is to light. A film with a higher ISO number is more sensitive and, therefore, recommended in low light levels. See also ISO.

Filter factor: A figure indicating how much light a filter absorbs, thus requiring an increase in exposure when the filter is used.

Focusing screen: On single lens reflex cameras, the mirror projects the image to the focusing screen.

Glamour lighting: See Butterfly lighting.

Gray card: A card which reflects a known amount (18%) of the light falling on it. Metering from a gray card provides accurate exposure information in situations when the subject is not of average reflectance.

Hair light: An accent light used to illuminate the hair.

High key portraits: A portrait made up of mostly higher (lighter) tonal values (such as a subject with medium to light skin, dressed in clothes lighter than the subject's face and posed in front of a background composed of lighter tones).

Incident meter: An exposure meter that measures the light that falls on the subject. The reading is unaffected by the brightness or color of the subject.

ISO: An international standard used to indicate the sensitivity of a film. A higher number means a film with a higher sensitivity, i.e. a faster film.

Keylight: The dominant light source in a portrait lighting set-up.

Kicker light: An accent light, other than a hair light, that is used to accentuate a single area.

Light ratio: A term used to describe the difference in intensity between the keylight (or main light) and the fill light. It is usually expressed as a ratio, such as 3:1.

Low key portraits: A portrait made up of mostly lower (darker) tonal values (such as a subject with medium to dark skin, dressed in clothes darker than the subject's face and posed in front of a background composed of darker tones).

Main light: See Keylight.

Mask of the face: Describes the full front of the face, from hairline to chin.

Medium format: A film format larger than 35mm but not as large as 4x5 inches. The most popular medium formats are 4.5x6cm, 6x6cm, 6x7cm and 6x8cm. Medium format images are usually recorded on 120 or 220 rollfilm.

Middle gray: A tone of 18% gray. Light meters indicate an exposure designed to yield this "average" tonality on the subject.

Mixed key portrait: A portrait of a low key subject on a high key background, or vice versa (such as a subject in medium to dark clothing on a light background).

Modeling lights: Components of studio flash units which provide continuous light to guide photographers in setting up their lighting.

Monolights: Type of studio light source where each light has its own power supply.

Natural color film: Designed to produce natural color and record a full tonal scale. This

is the type of film usually recommended for portrait photography. See also Enhanced color film.

Overexposure: Occurs when the amount of light that hits the film is in excess of that needed to produce an accurate representation of the subject on film. The resulting transparency is lighter than desired (the negative is darker).

Parabolic reflector: A metal reflector that produces lighting effects with shadows that are more sharply defined than shadows produced by a light equipped with an umbrella or a soft box.

Print film: Records a negative image on the film, which is then printed on photographic paper as a positive.

Recycle time: The amount of time after discharge it takes a flash to recharge and be ready for another discharge.

Reflected meter: An exposure meter that measures the light reflected from the subject we are photographing.

Reflector: A device (normally white, silver or gold) used to reflect light from another source onto a subject. Commonly used to provide fill light.

Sharpness: The amount of detail recorded on the film or the final image.

Short lighting: A lighting pattern created by posing the subject in a 2/3 or 3/4 view and directing your keylight at the side of the face furthest from the camera.

Shutter: A device that is open a specific length of time to let light fall on the film.

Shutter speed: The length of time that the shutter in the camera or lens is open to let light travel to the image plane to make the exposure.

SLR camera: A camera type with a mirror that projects the image to the focusing screen for viewing. The mirror moves out of the way for taking the image.

Soft box: A light modification device used to increase the effective size of a light source, yielding a softer lighting effect.

Split lighting: A lighting pattern which divides the face along its center. Create split lighting by placing the keylight at a 45° angle to the subject's nose axis, then moving the light until the highlight patch disappears from the shadow side of the face.

Spot meter: An exposure meter that only measures a small area of the subject.

Tele-extender: A lens design that is used together with a camera lens to increase the focal length of the lens. The teleconverter is mounted between the camera and lens. A 2x converter doubles the focal length of the lens, a 1.4x converter lengthens the focal length 1.4x.

Telephoto lens: A lens that has a focal length longer than the standard (50mm for 35mm, 80mm for the 6x6 medium format).

Transparency film: Records a positive image on the film, an image where the colors are the same as in reality. Black is recorded as black, and white as white.

Umbrella: An umbrella-shaped light modification device used to increase the effective size of a light source, yielding a softer lighting effect.

Underexposure: Occurs when the amount of light which hits the film is insufficient to produce an accurate representation of the subject on film. The resulting transparency is darker than desired (the negative is lighter).

Viewfinder: The camera component that is used to view the subject (an optical viewfinder) or lets you view the image of the subject on the focusing screen (as on a single reflex camera).

Vignetting: Vignetting is a technique used to obscure unwanted detail and draw attention to the main subject. A vignetter can darken or lighten the affected area.

Vivid color film: See Enhanced color film.

Wide angle lens: A lens designed to cover a larger area than a lens of normal focal length when the two lenses are used at the same distance from the subject. The focal length of a wide angle lens is shorter than the focal length of a normal lens.

Zoom lens: A lens design where the focal length can be changed, within a certain range, by moving some of the lens elements.

Index

Other Books from
Amherst Media

Basic 35mm Photo Guide

Craig Alesse

Great for beginning photographers! Designed to teach 35mm basics step-by-step — completely illustrated. Features the latest cameras. Includes: 35mm automatic, semi-automatic cameras, camera handling, *f*-stops, shutter speeds, and more! $12.95 list, 9x8, 112p, 178 photos, order no. 1051.

Build Your Own Home Darkroom

Lista Duren & Will McDonald

This classic book teaches you how to build a high quality, inexpensive darkroom in your basement, spare room, or almost anywhere. Includes valuable information on: darkroom design, woodworking, tools, and more! $17.95 list, 8½x11, 160p, order no. 1092.

Into Your Darkroom Step-by-Step

Dennis P. Curtin

This is the ideal beginning darkroom guide. Easy to follow and fully illustrated each step of the way. Includes information on: the equipment you'll need, set-up, making proof sheets and much more! $17.95 list, 8½x11, 90p, hundreds of photos, order no. 1093.

Wedding Photographer's Handbook

Robert and Sheila Hurth

A complete step-by-step guide to succeeding in the world of wedding photography. Packed with shooting tips, equipment lists, must-get photo lists, business strategies, and much more! $24.95 list, 8½x11, 176p, index, b&w and color photos, diagrams, order no. 1485.

Lighting for People Photography, 2nd ed.

Stephen Crain

The up-to-date guide to lighting. Includes: set-ups, equipment information, strobe and natural lighting, and much more! Features diagrams, illustrations, and exercises for practicing the techniques discussed in each chapter. $29.95 list, 8½x11, 120p, b&w and color photos, glossary, index, order no. 1296.

Camera Maintenance & Repair Book 1

Thomas Tomosy

A step-by-step, illustrated guide by a master camera repair technician. Includes: testing camera functions, general maintenance, basic tools needed and where to get them, basic repairs for accessories, camera electronics, plus "quick tips" for maintenance and more! $29.95 list, 8½x11, 176p, order no. 1158.

Camera Maintenance & Repair Book 2

Thomas Tomosy

Build on the basics covered Book 1, with advanced techniques. Includes: mechanical and electronic SLRs, zoom lenses, medium format cameras, and more. Features models not included in the Book 1. $29.95 list, 8½x11, 176p, 150+ photos, charts, tables, appendices, index, glossary, order no. 1558.

Restoring the Great Collectible Cameras (1945-70)

Thomas Tomosy

More step-by-step instruction on how to repair collectible cameras. Covers postwar models (1945-70). Hundreds of illustrations show disassembly and repair. $34.95 list, 8½x11, 128p, 200+ photos, index, order no. 1573.

Big Bucks Selling Your Photography

Cliff Hollenbeck

A complete photo business package. Includes secrets for starting up, getting paid the right price, and creating successful portfolios! Features setting financial, marketing and creative goals. Organize your business planning, bookkeeping, and taxes. $15.95 list, 6x9, 336p, order no. 1177.

Outdoor and Location Portrait Photography

Jeff Smith

Learn how to work with natural light, select locations, and make clients look their best. Step-by-step discussions and helpful illustrations teach you the techniques you need to shoot outdoor portraits like a pro! $29.95 list, 8½x11, 128p, b&w and color photos, index, order no. 1632.

Guide to International Photographic Competitions

Dr. Charles Benton

Remove the mystery from international competitions with all the information you need to select competitions, enter your work, and use your results for continued improvement and further success! $29.95 list, 8½x11, 120p, b&w photos, index, appendices, order no. 1642.

Freelance Photographer's Handbook

Cliff & Nancy Hollenbeck

Whether you want to be a freelance photographer or are looking for tips to improve your current freelance business, this volume is packed with ideas for creating and maintaining a successful freelance business. $29.95 list, 8½x11, 107p, 100 b&w and color photos, index, glossary, order no. 1633.

Infrared Landscape Photography

Todd Damiano

Landscapes shot with infrared can become breathtaking and ghostly images. The author analyzes over fifty of his most compelling photographs to teach you the techniques you need to capture landscapes with infrared. $29.95 list, 8½x11, 120p, b&w photos, index, order no. 1636.

Wedding Photography: Creative Techniques for Lighting and Posing

Rick Ferro

Creative techniques for lighting and posing wedding portraits that will set your work apart from the competition. Covers every phase of wedding photography. $29.95 list, 8½x11, 128p, b&w and color photos, index, order no. 1649.

Professional Secrets of Advertising Photography

Paul Markow

No-nonsense information for those interested in the business of advertising photography. Includes: how to catch the attention of art directors, make the best bid, and produce the high-quality images your clients demand. $29.95 list, 8½x11, 128p, 80 photos, index, order no. 1638.

Lighting Techniques for Photographers

Norm Kerr

This book teaches you to predict the effects of light in the final image. It covers the interplay of light qualities, as well as color compensation and manipulation of light and shadow. $29.95 list, 8½x11, 120p, 150+ color and b&w photos, index, order no. 1564.

Infrared Photography Handbook

Laurie White

Covers black and white infrared photography: focus, lenses, film loading, film speed rating, batch testing, paper stocks, and filters. Black & white photos illustrate how IR film reacts. $29.95 list, 8½x11, 104p, 50 b&w photos, charts & diagrams, order no. 1419.

How to Operate a Successful Photo Portrait Studio

John Giolas

Combines photographic techniques with practical business information to create a complete guide book for anyone interested in developing a portrait photography business (or improving an existing business). $29.95 list, 8½x11, 120p, 120 photos, index, order no. 1579.

Computer Photography Handbook

Rob Sheppard

Learn to make the most of your photographs using computer technology! From creating images with digital cameras, to scanning prints and negatives, to manipulating images, you'll learn all the basics of digital imaging. $29.95 list, 8½x11, 128p, 150+ photos, index, order no. 1560.

Achieving the Ultimate Image

Ernst Wildi

Ernst Wildi teaches the techniques required to take world class, technically flawless photos. Features: exposure, metering, the Zone System, composition, evaluating an image, and more! $29.95 list, 8½x11, 128p, 120 b&w and color photos, index, order no. 1628.

Black & White Portrait Photography

Helen Boursier

Make money with b&w portrait photography. Learn from top b&w shooters! Studio and location techniques, with tips on preparing your subjects, selecting settings and wardrobe, lab techniques, and more! $29.95 list, 8½x11, 128p, 130+ photos, index, order no. 1626

Profitable Portrait Photography

Roger Berg

A step-by-step guide to making money in portrait photography. Combines information on portrait photography with detailed business plans to form a comprehensive manual for starting or improving your business. $29.95 list, 8½x11, 104p, 100 photos, index, order no. 1570

Professional Secrets for Photographing Children

Douglas Allen Box

Covers every aspect of photographing children on location and in the studio. Prepare children and parents for the shoot, select the right clothes capture a child's personality, and shoot story book themes. $29.95 list, 8½x11, 128p, 74 photos, index, order no. 1635.

Handcoloring Photographs Step-by-Step

Sandra Laird & Carey Chambers

Learn to handcolor photographs step-by-step with the new standard in handcoloring reference books. Covers a variety of coloring media and techniques with plenty of colorful photographic examples. $29.95 list, 8½x11, 112p, 100+ color and b&w photos, order no. 1543.

Special Effects Photography Handbook

Elinor Stecker Orel

Create magic on film with special effects! Little or no additional equipment required, use things you probably have around the house. Step-by-step instructions guide you through each effect. $29.95 list, 8½x11, 112p, 80+ color and b&w photos, index, glossary, order no. 1614.

Fine Art Portrait Photography

Oscar Lozoya

The author examines a selection of his best photographs, and provides detailed technical information about how he created each. Lighting diagrams accompany each photograph. $29.95 list, 8½x11, 128p, 58 photos, index, order no. 1630.

Family Portrait Photography

Helen Boursier

Learn from professionals how to operate a successful portrait studio. Includes: marketing family portraits, advertising, working with clients, posing, lighting, and selection of equipment. Includes images from a variety of top portrait shooters. $29.95 list, 8½x11, 120p, 123 photos, index, order no. 1629.

The Art of Infrared Photography, *4th Edition*

Joe Paduano

A practical guide to the art of infrared photography. Tells what to expect and how to control results. Includes: anticipating effects, color infrared, digital infrared, using filters, focusing, developing, printing, handcoloring, toning, and more! $29.95 list, 8½x11, 112p, order no. 1052

Camcorder Tricks and Special Effects, *revised*

Michael Stavros

Kids and adults can create home videos and mini-masterpieces that audiences will love! Use materials from around the house to simulate an inferno, make subjects transform, create exotic locations, and more. Works with any camcorder. $17.95 list, 8½x11, 80p, order no. 1482.

Photographer's Guide to Polaroid Transfer

Christopher Grey

Step-by-step instructions make it easy to master Polaroid transfer and emulsion lift-off techniques and add new dimensions to your photographic imaging. Fully illustrated every step of the way to ensure good results the very first time! $29.95 list, 8½x11, 128p, order no. 1653.

Black & White Landscape Photography

John Collett and David Collett

Master the art of b&w landscape photography. Includes: selecting equipment (cameras, lenses, filters, etc.) for landscape photography, shooting in the field, using the Zone System, and printing your images for professional results. $29.95 list, 8½x11, 128p, order no. 1654.

Wedding Photojournalism

Andy Marcus

Learn the art of creating dramatic unposed wedding portraits. Working through the wedding from start to finish you'll learn where to be, what to look for and how to capture it on film. A hot technique for contemporary wedding albums! $29.95 list, 8½x11, 128p, order no. 1656.

Studio Portrait Photography of Children and Babies

Marilyn Sholin

Learn to work with the youngest portrait clients to create images that will be treasured for years to come. Includes tips for working with kids at every developmental stage, from infant to pre-schooler. Features: lighting, posing and much more! $29.95 list, 8½x11, 128p, order no. 1657.

Professional Secrets of Wedding Photography

Douglas Allen Box

Over fifty top-quality portraits are individually analyzed to teach you the art of professional wedding portraiture. Lighting diagrams, posing information and technical specs are included for every image. $29.95 list, 8½x11, 128p, order no. 1658.

Photo Retouching with Adobe® Photoshop®

Gwen Lute

Designed for photographers, this manual teaches every phase of the process, from scanning to final output. Learn to restore damaged photos, correct imperfections, create realistic composite images and correct for dazzling color. $29.95 list, 8½x11, 120p, order no. 1660.

Creative Lighting Techniques for Studio Photographers

Dave Montizambert

Master studio lighting and gain complete creative control over your images. Whether you are shooting portraits, cars, table-top or any other subject, Dave Montizambert teaches you the skills you need to confidently create with light. $29.95 list, 8½x11, 120p, order no. 1666.

Fine Art Children's Photography

Doris Carol Doyle

Learn to create fine art portraits of children in black & white. Included is information on: posing, lighting for studio portraits, shooting on location, clothing selection, working with kids and parents, and much more! $29.95 list, 8½x11, 128p, order no. 1668.

Infrared Portrait Photography

Richard Beitzel

Discover the unique beauty of infrared portraits, and learn to create them yourself. Included is information on: shooting with infrared, selecting subjects and settings, filtration, lighting, and much more! $29.95 list, 8½x11, 128p, order no. 1669.

Black & White Photography for 35mm

Richard Mizdal

A guide to shooting and darkroom techniques! Perfect for beginning or intermediate photographers who wants to improve their skills. Features helpful illustrations and exercises to make every concept clear and easy to follow. $29.95 list, 8½x11, 128p, order no. 1670.

Infrared Wedding Photography

Patrick Rice, Barbara Rice & Travis Hill

Step-by-step techniques for adding the dreamy look of black & white infrared to your wedding portraiture. Capture the fantasy of the wedding with unique ethereal portraits your clients will love! $29.95 list, 8½x11, 128p, order no. 1681.

Dramatic Black & White Photography:
Shooting and Darkroom Techniques

J.D. Hayward

Create dramatic fine-art images and portraits with the master b&w techniques in this book. From outstanding lighting techniques to top-notch, creative darkroom work, this book takes b&w to the next level! $29.95 list, 8½x11, 128p, order no. 1687.

Studio Portrait Photography in Black & White

David Derex

From concept to presentation, you'll learn how to select clothes, create beautiful lighting, prop and pose top-quality black & white portraits in the studio. $29.95 list, 8½x11, 128p, order no. 1689.